FIRST STEPS
S E R I E S

Painting Heads and Faces

PAT CLARKE

NORTH LIGHT BOOKS
CINCINNATI, OHIO

About the Author

Primarily a self-taught artist, Pat Clarke has loved, studied and painted art since childhood. Much of her knowledge and inspiration have come through studying fine art in galleries and books. In recent years, she has studied with many contemporary fine art painters, always challenging herself to reach a higher plane. Her oil, acrylic and pastel paintings have won numerous awards from local and national juried shows.

Pat is best known for her decorative painting, an art form centered around beautifying functional surfaces such as furniture, trunks, trays and tinware with florals, portraits, landscape scenes, faux finishes and more. Pat holds the prestigious award of Master Decorative Artist with the Society of Decorative Painters. She has traveled extensively throughout the United States, Canada and Japan over the past twenty-five years, teaching her decorative painting techniques.

Pat is also a member of the Pleasant Hill (Missouri) Town & Country Art League and the Mid-America Pastel Society.

Other fine North Light Books are available from your local bookstore, art supply store or direct from the publisher.

04 03 02 01 00 5 4 3 2 1

Library of Congress Cataloging-in-Publication Data

Clarke, Pat.
 Painting heads and faces / Pat Clarke.—1st ed.
 p. cm.
 Includes index.
 ISBN 0-89134-856-5 (pbk. : alk. paper)
 1. Portrait painting—Technique. 2. Gouache painting—Technique. I. Title.
ND1302.C55 2000
751.4 ' 26—dc21
 99–43575
 CIP

Editor: Jennifer Long
Production Coordinator: John Peavler
Cover and interior designed by: Wendy Dunning

Special Thanks

To the many students I have had the privilege to teach through the past thirty years. Your enthusiasm and desire to succeed has inspired me to search for the right words to share my knowledge when teaching and writing.

To Greg Albert and Jennifer Long from North Light Books, thank your for your patience and guidance throughout the writing of this book. You have been great!

We can never know it all, but each day we are given can allow us to grow with God's beauty around us. He blesses us to see our visions. I thank Him and give Him the Glory.

Dedication

This book is dedicated to Jim, my husband and soul mate, who has always enabled me to have my dreams through his encouragement and love.

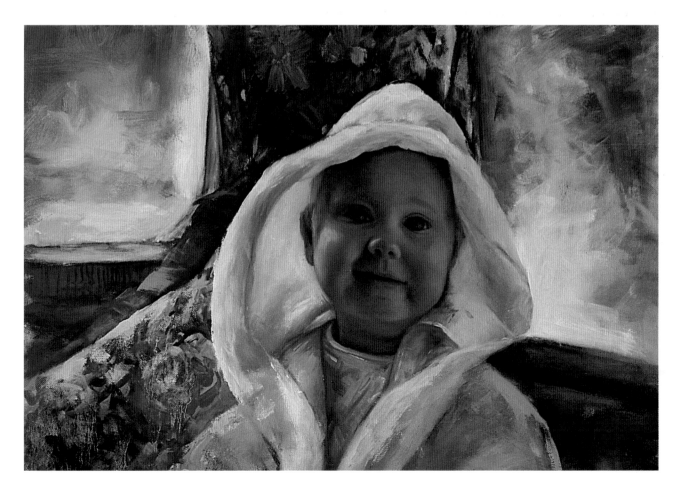

Table of Contents

Introduction

Have you ever wanted to paint a loved one, a friend or just someone who had an interesting facial feature or mannerism? Painting and sketching faces has been a longtime study of mine, and I can think of no other subject more interesting.

We all have two eyes, a nose and a mouth, yet we each have characteristics that make us special—no one else is exactly like us. Twins may look alike, and even act alike, but upon intent study you will always find something that sets them apart.

It is not just the shapes of our eyes, noses and mouths or the way the light strikes our faces that sets us apart from one another. Body language also has a great deal to do with the differences, such as the way a person holds his head or shoulders. Each of us has these unique characteristics.

In this book I will attempt to show you the basics of how to paint a face. We'll begin by learning to sketch a face using general vertical and horizontal guidelines. These general proportional rules will help keep the features in alignment. Next we'll learn how to draw and paint individual features. Finally, I'll show you how to adapt these basic features to represent a variety of ages, races and skin tones.

If you are a beginner to painting faces, I think it is best to start with generic faces, thinking only of general placement rather than trying to create a likeness. This gives you a chance to concentrate on your painting skills. As you learn, any painting you do will help you become a better portrait painter. The more you do, the better you will become.

It's also helpful to start noticing the faces around you. Look at the positions of features, and make mental notes of their placement. After you've learned the basics about painting faces, creating a likeness is just a matter of finding the special things about that face that differ from the basic face.

Please enjoy the process and don't become discouraged. As one saying goes, sometimes the journey is better than the destination.

Good luck and happy painting!

Part One

GETTING STARTED

A free, loose and expressive style of painting is my choice. When I began painting I was a "photographic" painter. Now, however, I express my painting language in a more impressionistic manner. Not only is it more fun and relaxing to paint this way, I find happy accidents with the paint puddling and making exciting statements on its own.

To me, when an artist "tells the whole story," creating the same amount of detail everywhere in the painting, the viewer appreciates the technical skill but loses interest quickly, as everything is already explained for them. I prefer to be entertained with a strong focal area created with high value contrast and detail, then to move within the resting areas containing much interest of color and value but little detail. There's a mystery in these loose, unexplained areas. Excitement is created when viewers find something they had not expected or did not notice on a previous viewing.

Acrylic paints are the best choice for this style. With acrylics you can achieve transparent washes, as in watercolor painting, but you can also build to opaque passages with detail in the focal area, the face and hair. This varied detail moves the eye through the painting.

I enjoy responding to the paint, always watching the paint's movement and value, allowing the paint to find its own level. This creates wonderful, happy accidents and

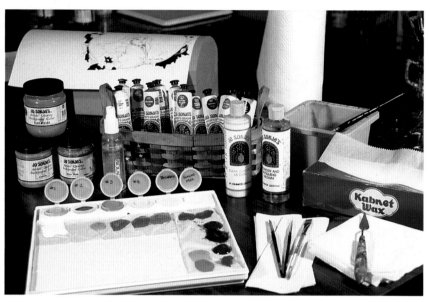

Here are some of my basic supplies. The large jars at left are the background colors; the tubes in the basket are the acrylic gouaches; the center bottles are the retarder and glazing medium. On the right are deli sheets, which I use in my Sta-Wet palette (bottom left) when painting backgrounds in a watercolor style, using lots of paint and water. I save the Sta-Wet paper for the flesh mixtures. Also shown are good, thirsty paper towels, my brushes, a palette knife for mixing large amounts of paint, my brush basin (which I set to my right when painting, with folded paper towels just below it) and a spray bottle for misting the paints on my palette.

keeps each painting session a new and exciting experience.

Paints

All of the lessons in this book are painted with Jo Sonja's Artist's Gouache, a versatile acrylic gouache that may be used as a solid basecoat or in a watercolor style. These paints are an ideal choice for first-time portrait painters.

Acrylic gouache has a few characteristics that are different from usual acrylics.

▶ Jo Sonja's Artist's Gouache is an acrylic matte finish paint, consisting of a lot of pigment with very little binder. Since binders tend to dry the paint, the shelf life of this paint is longer.

▶ Because this paint contains so little binder, you must use a sealer or glazing medium during the painting session. Without these mediums, a solid coat of paint that has not had several days to cure could reactivate when you blend and stroke the same area a number of times, causing a hole to form in the

paint. To avoid this, I use a hair dryer to force-dry the paint, allow it to cool, then paint over the area with glazing medium. The glazing medium puts a barrier between the previous paint and the new paint to be applied on top.

▶ Jo Sonja's Artist's Gouache stays wet a bit longer than other acrylics, and will allow you to clean up an edge of paint or remove it completely even after it has dried to the touch. This is a real plus for beginning students.

Removing Mistakes

You can remove gouache that has not been painted over or mixed with other mediums by moistening the area with a bit of water on a brush, then using a Q-tip to remove the paint.

Mediums

All Purpose Sealer

Jo Sonja's All Purpose Sealer is a pure acrylic sealer with remarkable adhesive power. I mix the sealer with paint when I basecoat a wooden surface prior to painting a design on it.

Mix 60 percent paint to 40 percent sealer for the first coat. Dry overnight or force-dry with a hair dryer. Always allow the surface to cool after force-drying.

If the second coat will be drying overnight, apply undiluted paint for the second coat. If you wish to paint the design immediately, add 10 percent glazing medium to the second

coat and force-dry with a hair dryer. When cool, apply the design.

Glazing Medium

Jo Sonja's Clear Glazing Medium is a great product that will lightly seal the previous layer of paint, acting as a barrier to reactivation. It will also help you add depth to the painted surface by allowing you to add several layers during one painting session. I use the glazing medium after I've applied the first basic coats. I then dry the area with a hair dryer and allow it to cool before proceeding to the next coats of paint.

Use the glazing medium periodically during the painting session, especially when you apply heavier coats of paint or use blending techniques, and after each use of retarder. Dry the retarder and paint thoroughly before applying the glazing medium.

Retarder

Jo Sonja's Retarder and Antiquing Medium lengthens the open wet time of paint, allowing you to blend colors.

A note of caution: Overusing retarder can soften the under layers of paint. If the paint has not cured sufficiently, or too many layers of retarder have been used without heat curing, a hole might occur if you blend or stroke the same area too long.

To avoid this problem, dry the area sufficiently with a hair dryer, allow it to cool and paint the area with glazing medium. This sets up a barrier between the underlying paint

and the paint to be applied to the top. Dry thoroughly with heat and cool before applying more paint.

When painting faces, I limit my use of retarder to the first application of blush to the face and later when doing the highlights.

Otherwise, I use water to moisten the dried surface before I apply more paint, when blending or when I desire a gradual fading of color.

Finishes

Gloss and Matte Varnishes

Jo Sonja's Polyurethane Water Based Varnish produces a protective finish of exceptional toughness, flexibility and abrasion resistance.

For a beautiful, durable final finish on painted pieces, I make a half-and-half mixture of the gloss and matte varnishes. Apply two to three coats, drying sufficiently between coats. Allow to dry thoroughly at least 24 to 48 hours, depending on the weather conditions in your area. You may also force-cure the varnish with a hair dryer.

Finishing Wax

If you are painting on a wooden piece (see "Starting Small" on page 8), after varnishing, apply Goddard's Cabinet Maker's Wax with a Scotch Brite pad or no. 400 steel wool. Allow the wax to dry about 10 minutes, then buff to a beautiful finish with a soft cloth.

Shopping List

Jo Sonja's Artist's Gouache
Not all of these colors are used in every project. You may start with a basic palette, then purchase the colors followed by an asterisk as needed.
- Amethyst
- Brilliant Magenta*
- Brown Earth
- Burgundy
- Burnt Sienna*
- Cadmium Orange*
- Cadmium Yellow Mid
- Carbon Black*
- Cobalt Blue*
- Dioxazine Purple
- Gold Oxide
- Moss Green
- Napthol Crimson
- Napthol Red Light
- Norwegian Orange
- Prussian Blue*
- Purple Madder*
- Raw Sienna*
- Sap Green*
- Titanium White
- Ultramarine Blue
- Vermilion
- Warm White*
- Yellow Oxide

Jo Sonja's Artists' Quality Background Colors
- Burnt Umber
- Dove Grey
- Oakmoss
- Vellum

Mediums
- Jo Sonja's All Purpose Sealer
- Jo Sonja's Clear Glazing Medium
- Jo Sonja's Retarder and Antiquing Medium

Loew Cornell Brushes
- Series 7550, ½-inch (12 mm) and 1-inch (25 mm) flats
- Series 7300, no. 6 flat
- Series 7500, no. 6, 8, 10 and 12 filberts
- Series 801, no. 1 liner
- Series 7350, no. 6 liner

Supplies for Painting on Wood
- Goddard's Cabinet Maker's Wax
- J.W. etc. Wood Filler
- Sandpaper, medium grit
- Scotch Brite pad or no. 400 steel wool
- Soft cloth
- Tack cloth

Other Supplies
- Brush basin
- Deli paper sheets, or palette paper
- Gesso, white
- Hair dryer
- Jo Sonja's Polyurethane Water Based Varnish, Gloss and Matte
- Paper towels
- Palette knife
- Sponge roller, 3-inch (17.8 cm)
- Spray bottle
- Sta-Wet palette
- Storage cups or film canisters
- Stylus
- Super Chacopaper or graphite paper
- Tape
- Tracing paper
- Q-tips
- Untempered Masonite board, wooden fan or box, or preprimed, stretched canvas

Preparing Your Surface

Starting Small
Beginning painters may find filling a large white canvas a little intimidating when making a first attempt at portrait painting. I suggest starting on something smaller and less expensive, like one of the many small wooden boxes, trays or Masonite boards available at craft and hobby stores. Many of the first projects in this book are painted on small wooden surfaces or untempered Masonite board.

A smaller design area allows you to concentrate on the portrait, without worrying too much about clothing or background. In addition, an inexpensive surface will take the pressure off (this doesn't have to be a masterpiece!), allowing you to have fun and experiment—and these surfaces make great heirloom pieces and gifts.

Preparing Wooden Surfaces
To prepare wooden surfaces for painting, fill all nail or screw holes with J.W. etc. Wood Filler, then dry sand the wood with medium grit sandpaper, going with the grain. Pay careful attention to the open areas of the wood, such as the routed edges or where the pieces of wood come together. Use a tack cloth to remove dust.

To prepare a Masonite board, sand with medium grit sandpaper lightly to roughen the surface slightly.

Applying Gesso
Apply a coat of white gesso to Masonite boards and wooden surfaces with a 3-inch (17.8 cm) sponge roller. Leave a bit of texture

on the painting surfaces. This texture, or tooth, however slight, will tend to hold the paint, making painting easier. If you create too much tooth, sand lightly.

If ridges of gesso occur at the edges, you have used too much gesso or applied too much pressure to the roller. Applying no pressure, roll the surface in all directions to lessen the amount of gesso on the surface, then roll in one direction, usually lengthwise.

If less texture is desired, allow the gesso to dry slightly, then roll softly over the surface several times.

Stretched canvas comes pre-primed with gesso, so no preparation is necessary.

I do not recommend using canvas panels (canvas glued to board). If you use them, prepare them with gesso as you would for Masonite.

Basecoating the Surface

After the gesso is dry, you are ready to apply your base (background) color.

For the first coat, mix 60 percent base paint and 40 percent sealer together. This will help reduce chipping. If you plan to allow the second coat to air dry, apply a second coat of undiluted paint and allow to dry for at least two hours or overnight.

If you wish to start painting immediately, add 10 percent glazing medium to the second coat of paint and force-dry it with a hair dryer.

Either technique will produce a matte finish on which to apply the design.

Transferring the Design

I have provided a line drawing for each project in this book. If you wish, you may use the drawing as a pattern, transferring every line directly onto your surface. However, I suggest you use the line drawings as guides, transferring only those lines that separate the different elements of the design and omitting the details. Do keep the original line drawing close at hand for reference.

Allowing yourself to draw these areas freehand will help you become better at judging proportion and less dependent on patterns.

Draw or trace the design onto tracing paper. Tape the design to the surface to keep the pattern from slipping.

I use Super Chacopaper to transfer my design. This is a transfer paper coated with chalk rather than graphite; your marks can be easily removed with water. Slip the transfer paper under the tracing paper, chalk-side down. Using a stylus, go over the lines of the drawing using light pressure (pressing too hard may indent the surface).

Setting Up Your Palette

The Sta-Wet palette will help keep your acrylic paints moist and workable longer than a traditional dry palette. It's especially important to keep the flesh mixtures wet so you don't have to remix them each time you use them.

To prepare the palette, soak the Sta-Wet palette paper in very hot water for 45 minutes or longer. Wet the Sta-Wet palette sponge and squeeze, allowing only a small amount of water to remain in the sponge. Place the wet palette paper on top of the sponge. Moisten two folded paper towels and place one across the top of the palette and the other along the right side (left side for left-handed people).

Place the paints along the top and down the side of the moistened towels in the order given in each project. Mix the flesh mixtures for the project you're painting and place them under the tube colors.

To save time, I prepare a good amount of my four flesh mixtures and store them in empty film canisters or airtight storage cups, marked with their number and color. I also put glazing medium and retarder in storage cups on my palette. This keeps everything close at hand so I can concentrate on my painting.

When painting backgrounds or basecoating, I cover the palette paper with deli-sheets (waxy sheets of paper used to separate meats and cheeses). These can be discarded when the background is finished, saving my Sta-Wet paper for the mixtures needed to paint the face.

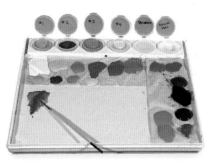

Set up your palette in the same order every time.

Painting the Portrait

1 When painting the portrait, I start with medium washes of color, using a half-and-half mix of paint and water. I basecoat each area of the drawing with two or three coats of paint, gradually building to a solid coverage, rather than applying one solid coat of paint.

The paint dries very quickly when mixed with water and does not reactivate as easily. I do use a hair dryer occasionally at this stage to force-dry an area, but most often I allow the area to air dry.

2 While one area is drying, I go to another area of the painting to paint the basic colors. I keep moving around the painting, then coming back to the first areas after the paint has had a bit of drying time to add another coat for a more solid coverage.

This method not only prevents holes in your base layers, it helps you see the color relationships more accurately, since the colors will be a bit darker when dry.

3 After the first basecoats are dry, paint over the areas with glazing medium and force- or air dry.

4 Apply the second coat of paint. If you want to achieve an opaque coverage, use a bit less water and more paint. It will usually take two or three coats to achieve an opaque coverage, depending on the subject and background color. I paint over the area with glazing medium with every second or third application of paint, especially when building to opaque coverage, to keep the paint from reactivating.

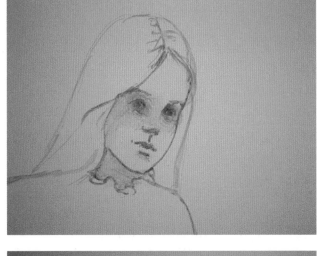

Start with medium washes.

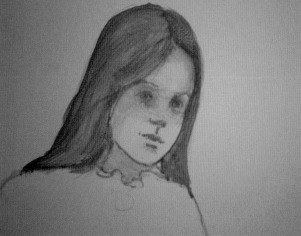

Move around the painting, allowing the first areas to dry.

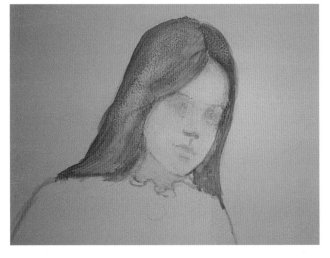

Apply additional coats to build to an opaque coverage.

5 When using retarder, force-dry with a hair dryer, cool the surface and apply glazing medium.

Part Two

LEARNING TO DRAW FACES

Observing people and training your eye to see the unique characteristics of each face is an interesting and ongoing skill. We all know a person's face has two eyes, a nose and a mouth, yet each face has its own distinguishing traits.

When you begin to draw portraits, it is important to know some general horizontal and vertical lines of measurement that help to portray a face. Once you've learned to draw faces using these general guidelines, not trying for a likeness of anyone in particular, you will begin to distinguish the way the portrait you wish to represent differs from the general feature placements.

Start With General Rules of Placement

Creating a likeness is a matter of constantly relating one feature to another and observing how the shapes and placement of the features you're representing differ from the general rule. These practice portraits are not necessarily great drawings, but practice in referring to vertical and horizontal guidelines is invaluable. This practice will give you some knowledge and skill to fall back on when the portrait you are drawing or painting is less than you had hoped to achieve.

Faces viewed from the front resemble an egg shape. As the head turns to either side, the far side of the face shows less. At the same time, more of the closer side shows, along with some of the back of the head. It is most important to plant firmly in your mind the view of the head you are representing.

Learning to use horizontal and vertical guidelines when drawing the face in the beginning will help you keep the features in tune with the view you are drawing.

Horizontal Guidelines

1 The first line falls approximately half the distance from the top of the head to the chin. On an adult, the eyes and brows fall within this area. The halfway horizontal measurement on a baby or toddler falls approximately at the brow line—the forehead is a bit larger and the features fall within the lower part of the face. On children from approximately five to six years old to adulthood, the line varies, falling somewhere in between the eyes and brows. The eyes seem to move up as the child ages.

2 The second horizontal line, falling approximately one-third the distance from the eye line to the chin, marks the bottom of the nose. Children's noses fall a bit higher.

3 The third line is approximately half the distance from the nose line and indicates the center of the mouth.

4 The ears generally start at the top horizontal line and end at the middle (nose) line.

Vertical Guidelines

1 The main vertical line indicates the center of the face. This line helps to keep the features aligned and helps you to not distort the bottom of the face when painting and drawing three-quarter faces. Divide the face in half vertically.

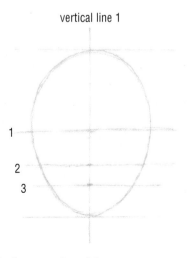

The horizontal guidelines.

2 Draw a circle on either side of the vertical line, spaced over just a bit from the center line. Shade in these areas, which represent the eye sockets.

3 Place the eyes at least one eye-width apart, just below the eye line and within the shaded area. Draw in the irises and shade the entire iris.

4 From the inner corner of each eye, bring a line down to the nose line. These indicate the sides of the nose.

5 From the inner edge of each iris, draw a line down to the mouth line to indicate the outer corners of the mouth.

Practice a Basic Face

Using the horizontal and vertical guidelines, let's draw a general child's face with a front, level view.

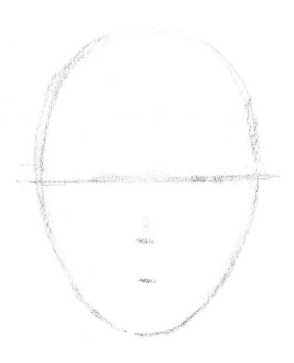

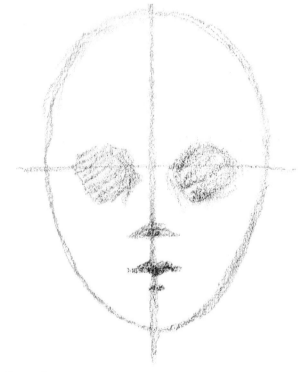

Step 1
Viewed from the front, the shape of the face is much like an egg. Divide this into sections horizontally, beginning approximately halfway between the top of the head and the chin. The next line will be the nose line, approximately one-third the distance from the first line. The mouth is approximately half the distance from the nose line.

Step 2
Divide the face in half vertically. Draw a circle on either side of the vertical line, leaving a bit of space from the center line. Shade in these circles, representing the eye sockets. Shade the bottom of the nose up to the tip, and shade a bit of the upper lip. Place a line to suggest the lower lip.

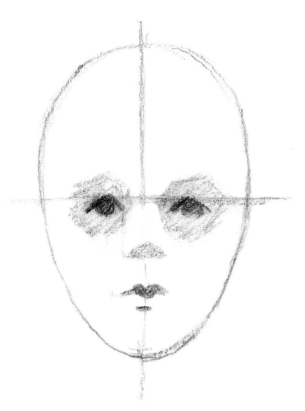
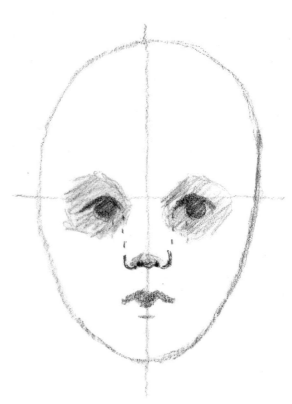

Step 3

Place the eyes at least one eye-width apart, just below the eye line (since this is a child's face) and within the shaded area. Draw only the upper eyelid line and the round shape of the iris, then shade the entire iris.

Step 4

From the inner corner of each eye, bring a line down to the nose line to indicate the sides of the nose. Form the sides of the nose and indicate nostrils on either side of the center line.

Adapting the Eyes for a Child's Face

The first horizontal line most often falls within the eye; however, in younger children it falls above the eye and nearer the brow. Younger children have larger foreheads, and their features are larger in relation to size of the rest of their face. This is especially true of the eyes, which are a bit wider set than an adult's. As the child grows and reaches approximately 12 to 13 years, the eye falls on the center horizontal line, more like an adult face.

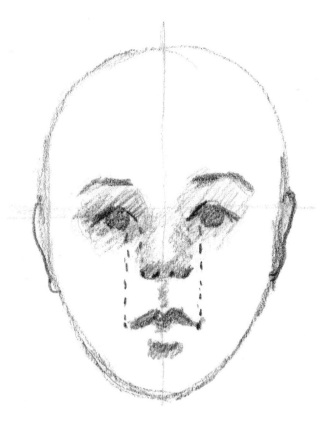

Step 5

From the inner edge of each iris, draw a line down to the mouth line to indicate the outer corners of the mouth. Add more shading to the upper lip, the indentation above the upper lip, the indentation below the lower lip to the center of the chin and some shading on the sides of the nose and through the eye area, connecting the eye cavities. Suggest ears on the sides, beginning just below the brows and ending at the bottom level of the nose.

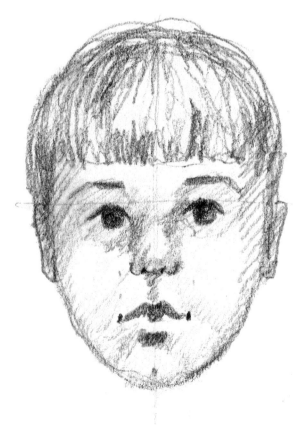

Step 6

Shade the side planes of the face, the ears and the receding areas on the jaws and chin. Add hair, which makes the head a bit larger since it stands out from the head on the top and sides. This could be a boy or a girl. You have just completed your first face—and with success, I'm sure!

Front View Level Face

Here's another front view, level face. This time we're drawing the face of a girl who is close to adulthood; therefore, the top of her eye line will fall on the first horizontal line, rather than below it.

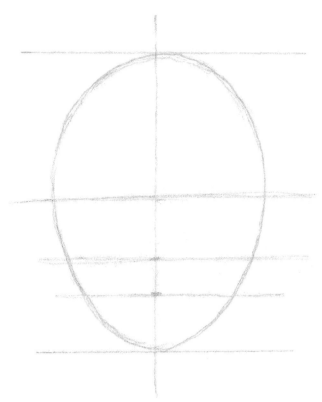

Step 1

The head is basically an egg shape. Divide the shape in half vertically. This line will keep the features in alignment; everything on either side of this line should be equal in measurement.

Step 2

Now draw the halfway line horizontally to find the eye area. Draw the nose line approximately one-third (or a bit less) the distance from the eye to the chin. It's better for the nose to be too high than too low. Draw the center of the mouth half the distance from the nose line to the chin.

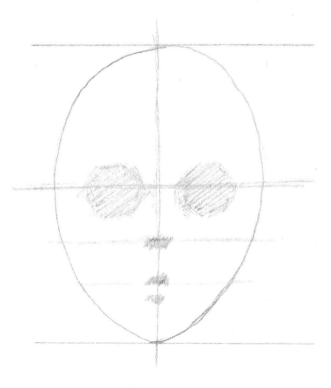

Step 3

Now, thinking of a skeleton, shade the whole eye cavity from the brow to below the eye and a bit to each side of where you think the eye will sit. Also shade the bottom of the nose, the top lip and the area under the lower lip. Already the face is taking shape.

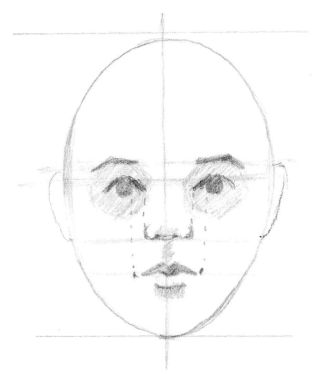

Step 4

Now place the top line of the eye on the top horizontal line, and draw in the iris, taking care to stay well within the socket area and allowing approximately the width of an eye or more between the eyes. The eyes should not be too close together. The width of the face should be approximately five eye-widths across.

From the inside corner of each eye, make a dotted line down to find the side of the nose. From the inner edge of each iris, make a dotted line down to find the corner of the mouth.

Place the mouth center and build the top lip above the line. To make the top lip, start with a long triangle, then cut in a **V** where the top point should be to suggest the bow part of the mouth. The shadow of the indentation above the upper lip falls within this **V**.

Create a shadow from the lower portion of the lower lip to approximately the upper center of the chin.

Now place the ears, beginning at the eyebrow level and following down the cheek to the bottom of the nose. You will not see the ear fully, only a suggestion of the outer edge.

Step 5

You are now ready to put some hair on the head. This will make the head look a bit bigger. Bring the hair out beyond the head on the top and sides.

Shade a bit on the face around the edges of the head to recede this area, and on the nose and cheeks.

Congratulations! You have successfully finished your face. I promise you each face you sketch from here on will be easier, and you will be able to do it more accurately and faster the more you practice!

Making the Face Younger or Older

How old do you think this face would be? I think this would be a young adult, approximately 13 to 14 years old. To make this face look younger, you would need to show a bit more forehead, lower the eyes a bit and place the other features a bit closer together and more within the lower portion of the face. Making the face a bit rounder and setting the eyes a bit wider also helps to make a younger looking face.

To make the face older, center the eyes directly on the eye line and leave only one eye-width between the eyes. Raising the eye line will affect all the other features, raising them higher in the lower portion of the face.

Three-Quarter View Level Face

Now let's draw a three-quarter view face.

Step 1

As the head turns to the side, the center vertical line begins at the top center of the oval, but as it moves toward the middle of the face, it curves with the egg shape toward the side the head is facing. The line comes back to center at the bottom of the oval.

Note that on a three-quarter face less of the far side of the face is visible, and very little or none of the ear on the far side of the head can be seen. The side nearest us has an entire ear visible and part of the back of the head. To find the horizontal eye line, divide the face in half from the top of the head to the chin, curving the line up slightly in the center to follow the egg shape of the face.

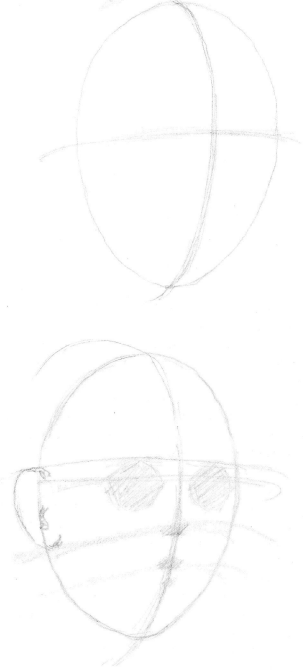

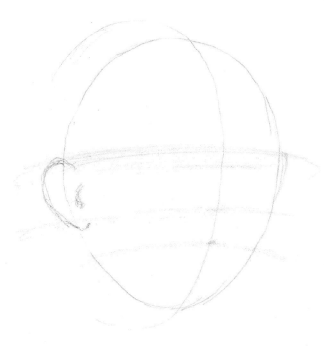

Step 2

Find the nose and mouth lines as you did for the frontal view face, this time curving the lines slightly up in the center. In this step I've also added an eyebrow line above the eye line. Place the ear at the eyebrow line, and angle the ear to reach the bottom of the nose. Place the ear within the edge of the oval, rather than outside it.

Step 3

Shade the bottom of the nose, the top lip and under the bottom lip, and the eye sockets.

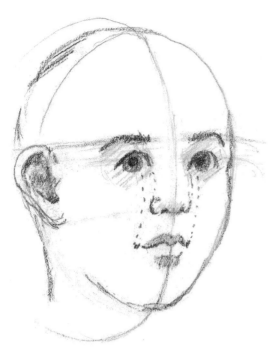

Step 4

As you can see, the back of the head shows a bit and continues into the neck behind the ear. Erase the left side of the oval line near the ear, since this area will be a lost edge fading into the neck.

Place the eyes within the eye cavity, turning the iris to look at us with more white of the eye showing on the right. Find the inner corners of the eyes and follow down to find the bottom of the nose.

Now from the right side of the iris on the left, follow down to find the corner of the mouth. The right eye is foreshortened (this side of the face is going away from the viewer), so follow down from the pupil to find the corner of the mouth. The far side of the mouth is also foreshortened, so make the line from the center shorter than on the side near us.

Step 5

In this step I have placed the hair out beyond the head and shaded a bit on the face. This girl is a bit older than the previous one, maybe 16 years old, so her feature placement is nearly that of an adult.

Keeping Your Features in Line

The center line is the most important guide for keeping features in alignment. Even if I don't always draw it, I mentally calculate its position. If I have trouble with the lower features drifting too much from the three-quarter view, I use the center line as a reference point.

I had trouble with this when I began drawing—I could get the eyes to read three-quarter view, but the lower part of the face would tend to drift back to frontal view and look a bit twisted. Using horizontal and vertical lines helped me learn to keep all my features in alignment.

Adjust the Basic Guidelines to Capture a Likeness

I created the previous faces from my imagination to demonstrate general placement of features. I recommend you practice drawing general faces like these until you're familiar with the basic horizontal and vertical guidelines.

When you're ready to draw a portrait that looks more like a specific person, start with a photograph of that person. Refer to the photo to see how the placement of that person's features differs from the general guidelines. Compare the distances and placement of one feature to another. Are the eyes more or less than one eye-width apart? Is the mouth wider or narrower than the lines you've drawn from the edges of the irises? Adjust your lines to match the photo.

Of course, you will also need to study the shape of the eyes, nose and mouth. When a strong light source is evident, you will use the shadow patterns to help relay an accurate version of the face. We'll worry about drawing specific features and planes of the face later; for now, let's concentrate on feature placement.

On the previous pages I've demonstrated full frontal and three-quarter level views, as these are the most common views used in portraiture. On the next few pages I've drawn from photos of real people, including some other angles you may encounter. Remember to always find the center vertical line first, then proceed to the horizontal guidelines when drawing any of the faces.

Young Boy Front View

Reference photo.

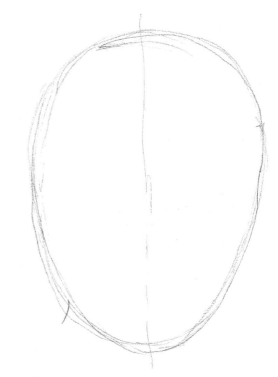

Step 1

19

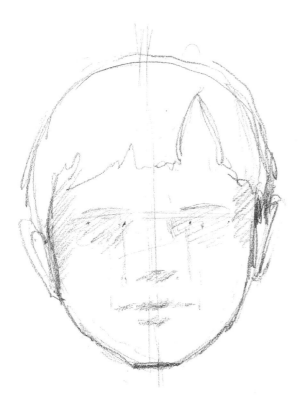

Step 2

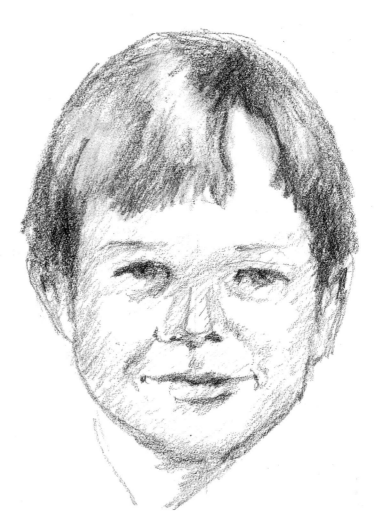

Step 3

Young Boy Three-Quarter View

Reference photo.

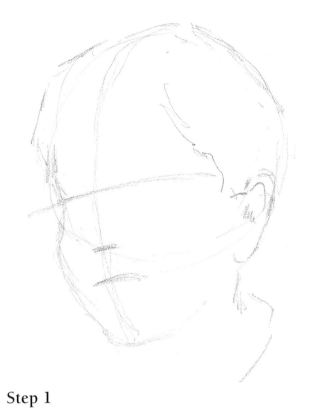

Step 1

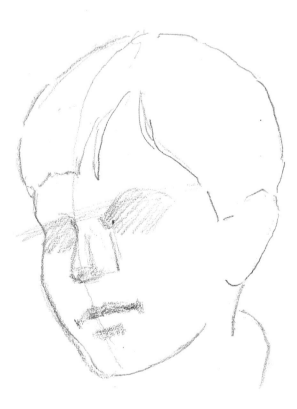

Step 2

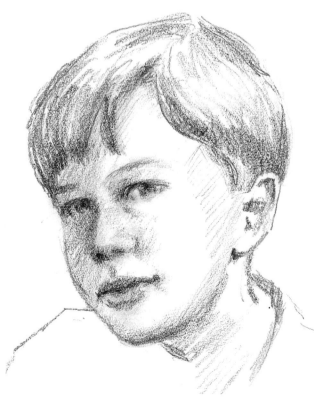

Step 3

Young Boy Side View

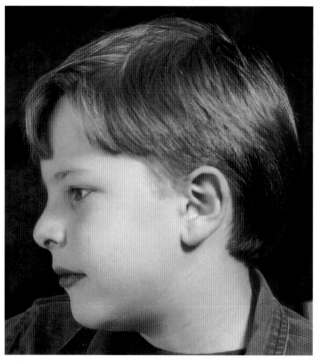

Reference photo.

Step 1

Step 2

Step 3

Toddler Front View

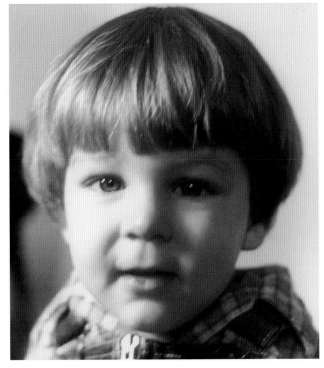

Reference photo.

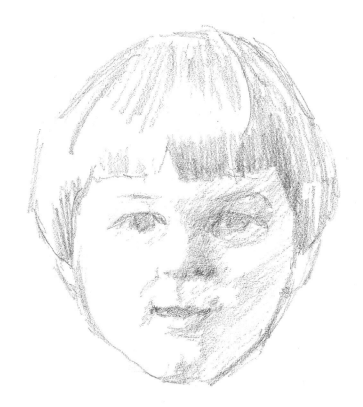

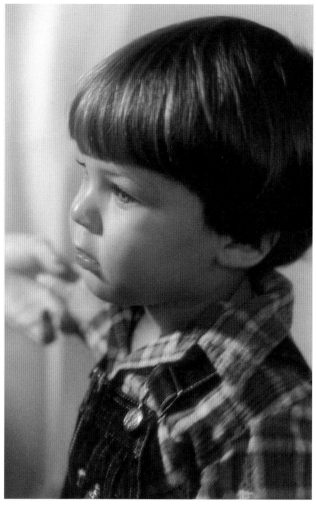

Reference photo.

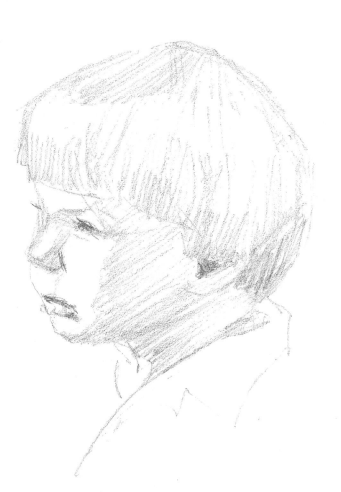

Understanding the Planes of the Face

If you were to chisel a face from stone or wood, you would have a different plane for each area of the face that changed directions. It helps to think of and see the planes in this way to better understand and see the effect of light when it hits the face.

Compare the examples on pages 25-26 to see how the light source affects the different areas. As you shade and paint your faces, these planes will be more evident to you.

THREE-QUARTER VIEW, UPPER LEFT LIGHTING
The strongest areas of light fall on the left side of the fore-head, the nose, eye, cheek, above the upper lip, the lower lip and the upper chin on the left. The light hits only small areas of the right side of the face: on the upper eyelid and on the right cheek. Reflected lights are apparent on the far right side of the head, cheek and neck.

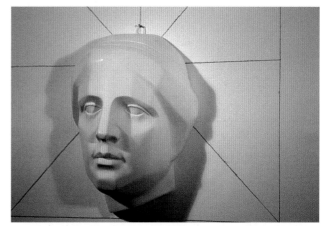

THREE-QUARTER VIEW, UPPER RIGHT FRONTAL LIGHTING
The strongest light falls on the planes of the central forehead, the nose, the upper eyelid on the left and above the upper lip, the lower lip and the upper chin. Light also catches on the right eyelid and top of the right cheek.

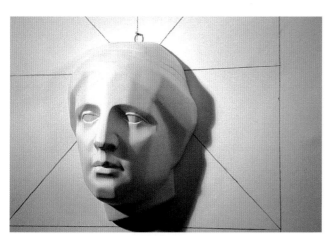

THREE-QUARTER VIEW, UPPER LEFT FRONTAL LIGHTING
The strongest light catches on the left forehead and nose, the upper cheek, above the upper lip, on the lower lip and the upper chin areas. On the right it catches on the right eye and upper cheek and in small areas on the cheek next to the mouth. Reflected lights are apparent on the right side of the head, face and neck.

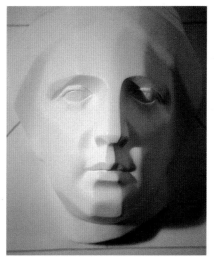

FULL FRONT VIEW, LEFT FRONTAL LIGHTING
The strongest light catches on the left side of the forehead, the nose, eyelid, cheek, the left area above the upper lip, the left side of the lower lip and the left side and center of the chin. On the right side, the light catches small areas on the right eyelid and right cheek near the mouth.

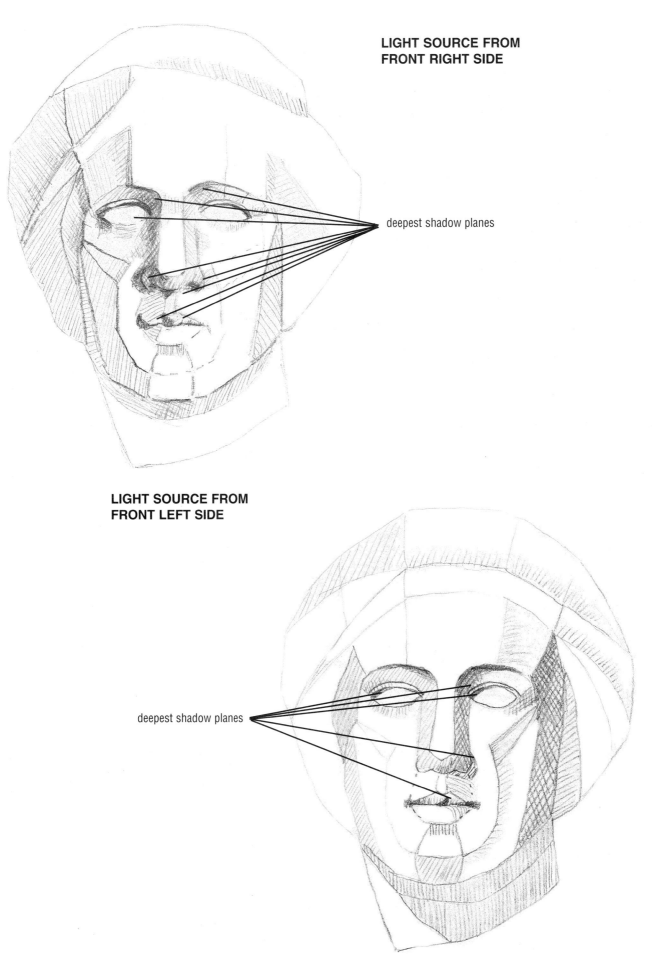

**LIGHT SOURCE FROM
FRONT RIGHT SIDE**

deepest shadow planes

**LIGHT SOURCE FROM
FRONT LEFT SIDE**

deepest shadow planes

Part Three

FEATURING THE FEATURES

Drawing Basic Eyes

Step 1

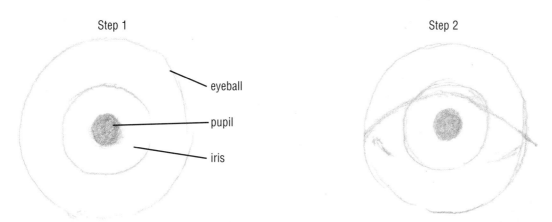

Step 2

Steps 1 & 2

Start with a circle for the eyeball. Inside, add another circle for the iris, then a smaller circle inside that for the pupil. In Step 2, I've begun to place the eyelid over the eyeball. The top and bottom eyelids meet at the edges of the eyeball.

Step 3

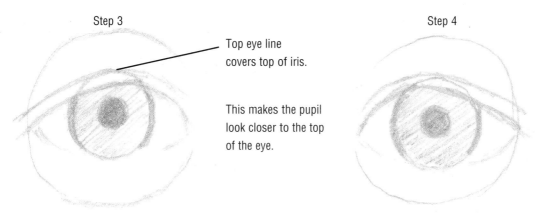

Top eye line covers top of iris.

This makes the pupil look closer to the top of the eye.

Step 4

Steps 3 & 4

Step 3 shows the curve of the eyelid. When the eye is open, the lid covers a bit of the top of the iris. In Step 4, note that the pupil is closer to the top of the eye opening because part of the iris is covered by the eyelid.

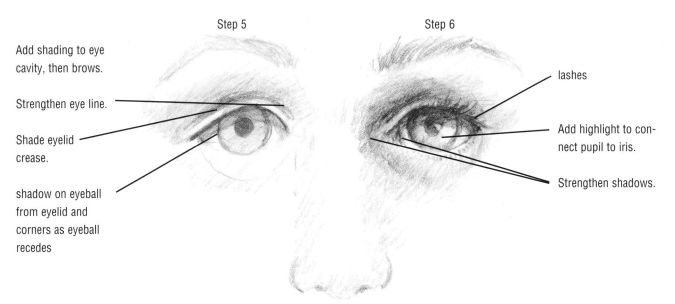

Step 5

Step 6

Add shading to eye cavity, then brows.

Strengthen eye line.

Shade eyelid crease.

shadow on eyeball from eyelid and corners as eyeball recedes

lashes

Add highlight to connect pupil to iris.

Strengthen shadows.

Steps 5 & 6

Strengthen the eye opening line at the top. Note the shadow that the eyelid casts upon the eyeball and iris and the shadows on the eyes as they recede into the corners. Shade the eyelid crease above the eye. In Step 6, strengthen shadows in the inner corner and above the eyelid in the eye cavity, also suggesting a bit of the fleshy part on the inner corner of the eye. Lashes are placed coming from the eye opening line, with the longest lashes at the 10 o'clock position on the left eye, the 2 o'clock position on the right eye. The highlight connects the pupil to the iris. Eyebrows most often do not begin closer than just above the inside corners of the eyes vertically.

Drawing the Basic Eye from Different Angles

When drawing the eye, the eyeball area is just as important as the iris and pupil. The eyes are connected and work together, so as you draw make sure the eyes are tracking properly.

The amount of white eyeball showing on the inner corner of one eye should be about the same as that showing on the other eye's outer corner and vice versa. The exception is when the eye is turning to the side, from the three-quarter view on: The far eye will be foreshortened the farther the face turns away, showing less of the far side of the eye. When beginning to paint eyes, it's best to keep the eyes tracking together.

The pupil will always be visible

and will remain round in front view and three-quarter view faces that are looking toward the viewer, as in the illustration on page 21. As the eye looks more to the side, the pupil could become a bit more oval.

The eyelid should not cover any part of the pupil, but it could touch the top of the pupil, throwing the pupil into shadow and making the pupil seem to be covered. The size should always appear appropriate to the size of the iris.

Upward Looking Eye You will see the bottom of the white eyeball area under the eye if the eye is looking up. This is often the case with children, since they are smaller and often look up. The eye shape appears more rounded at the top as it looks

up (see illustration at right).

You will not often see the white eyeball area at the top of the eye, unless the subject is surprised or scared.

Downcast Eye The downcast eye will show more of the eyelid, and the iris will be covered not only by the upper lid but also by the lower lid.

Side View Eye The side view of an eye will show the iris and pupil as vertical ovals, with the pupil in the front section of the iris. The eyelid wraps around the eye and the lashes will look longer, since they are not foreshortened as in the front and three-quarter views. The lower lashes may also be visible but will sit away from the eyeball, leaving a lower lid visible.

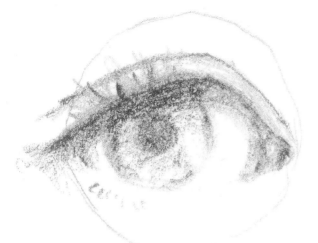

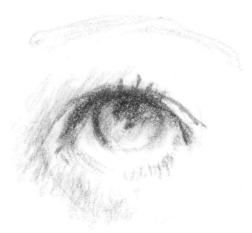

SIDE GLANCE EYE

UPWARD LOOKING EYE

This eye looks up, showing more white eyeball area at the bottom. Children look like this a lot.

DOWNCAST EYE

SIDE VIEW EYE

The iris and pupil are oval shaped, and the pupil is toward the front of the iris. The eyelid crease is out over the front of the iris and pupil.

Painting the Basic Caucasian Eye

Front View

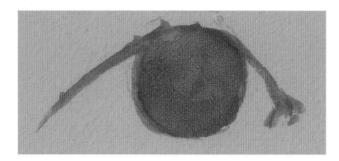

Step 1
Outline the top eye line with a no. 1 liner and fill in the iris with flesh mix 2 + water. (See the projects beginning on page 57 for the appropriate flesh mixtures.)

Strengthen.

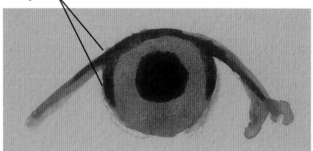

Step 2
Add the pupil in the center of the iris with the no. 1 liner. Strengthen the top line and sides of the iris with Brown Earth + Ultramarine Blue + water.

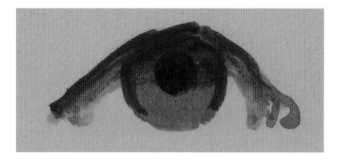

Step 3
Paint the eyeball area with mix 1 + a touch of water on a no. 1 liner. Allow to dry. Paint Brown Earth + water halfway down on the iris and under the eye line on the eyeball area to create the shadows from the lid onto the eyeball and in the corners as they recede.

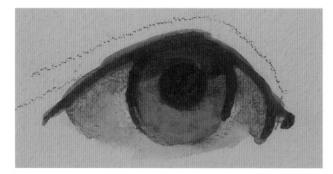

Step 4
Use a no. 1 liner and Cadmium Orange on the lower portion of the iris. Soften the edges as you reach the halfway point.

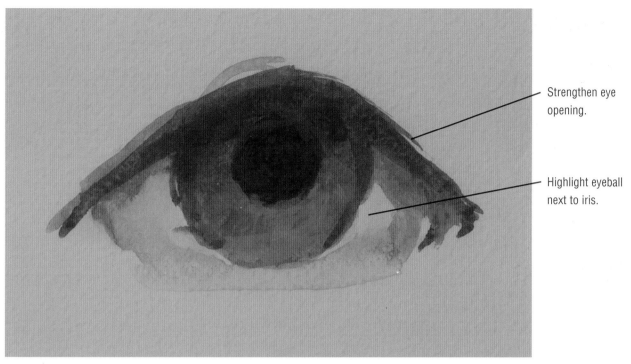

Strengthen eye opening.

Highlight eyeball next to iris.

Step 5
Strengthen the eye opening with Brown Earth + Ultramarine Blue + water on a no. 1 liner. Highlight next to the iris on the eyeball with more mix 1 + a touch of mix 4.

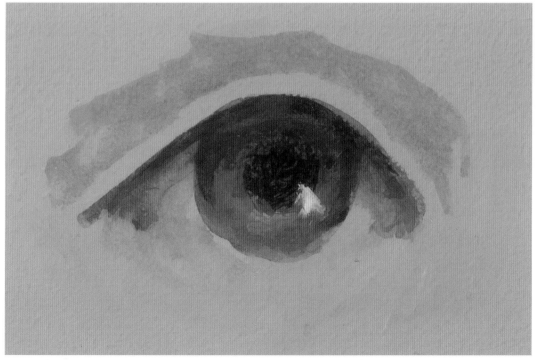

Step 6
Highlight the eye, connecting the pupil to the iris at four o'clock with mix 4 + more Titanium White on a no. 1 liner. Soften the edges.

Side Glance Eye

Step 1
Outline the top eye line and fill in the iris with flesh mix 2 + water on a no. 1 liner.

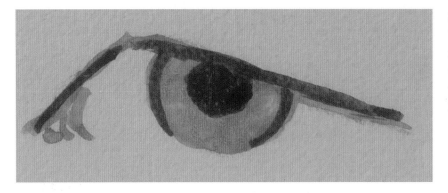

Step 2
With the no. 1 liner, add the pupil in the center of the iris. Strengthen the top line and sides of the iris with Brown Earth + Ultramarine Blue + water.

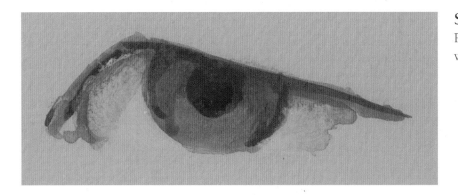

Step 3
Paint the eyeball area with mix 1 + water on a no. 1 liner. Allow to dry.

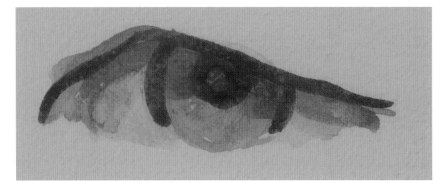

Step 4
Paint Brown Earth + water halfway down on the iris and under the eye line on the eyeball area to create the shadows from the lid onto the eyeball and in the corners as they recede.

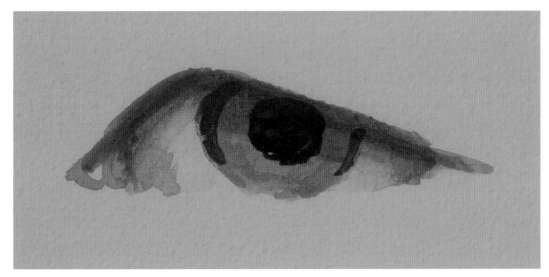

Step 5

Strengthen the eye opening and pupil with Brown Earth + Ultramarine Blue + water on a no. 1 liner.

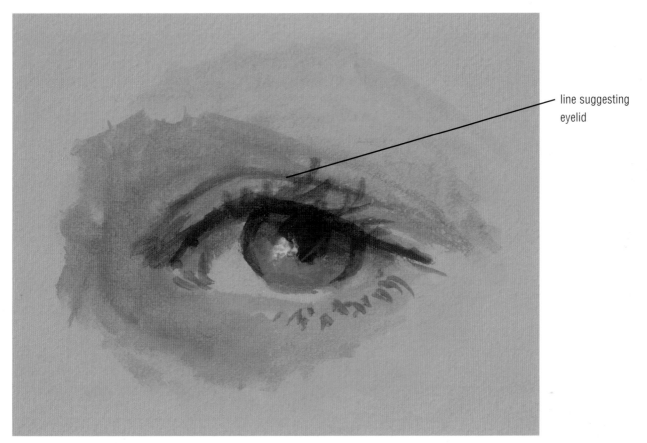

line suggesting eyelid

Step 6

Add mix 4 + Ultramarine Blue to the lower iris for blue eyes, using the no. 1 liner. Soften the edges. With the no. 1 liner, add a second line to suggest the eyelid, and soften. Highlight the eye, connecting the pupil to the iris at eight o'clock. Highlight the eyeball to the left of the iris with mix 4. Add a touch of Cadmium Orange + Vermilion to the inner corner of the eye. Add lash suggestions with Brown Earth + Ultramarine Blue + water.

Side View Eye

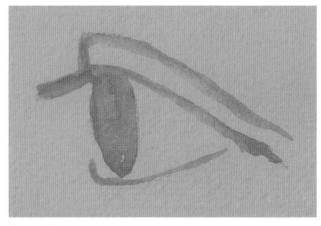

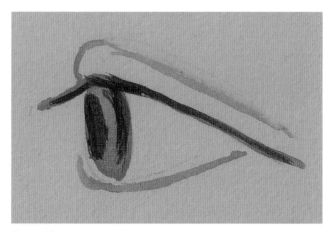

Step 1

Outline the top eye line and fill in the iris with flesh mix 2 + water on a no. 1 liner.

Step 2

Add the pupil in the center of the iris with a no. 1 liner. Strengthen the top line and sides of the iris with Brown Earth + Ultramarine Blue + water.

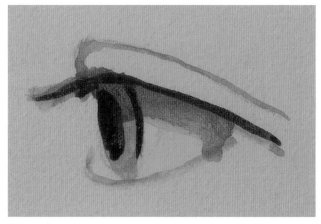

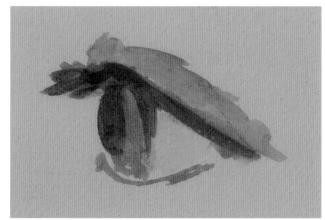

Step 3

Paint the eyeball area with mix 1 + water on a no. 1 liner. Allow to dry. Paint Brown Earth + water halfway down on the iris and under the eye line on the eyeball area to create the shadows from the lid onto the eyeball and in the corners as they recede.

Step 4

Strengthen the eye opening and pupil with Brown Earth + Ultramarine Blue + water on a no. 1 liner.

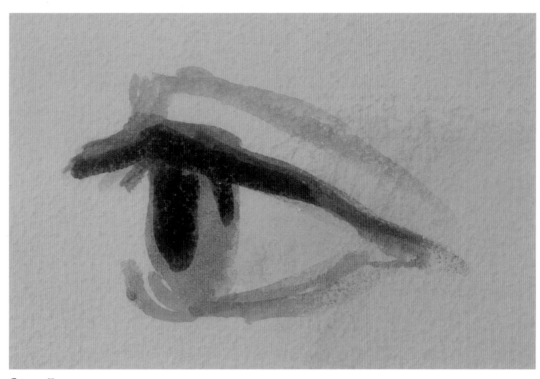

Step 5
Using a no. 1 liner, add mix 4 + Ultramarine Blue to the lower iris for blue eyes. (Shown below.) Soften the edges.

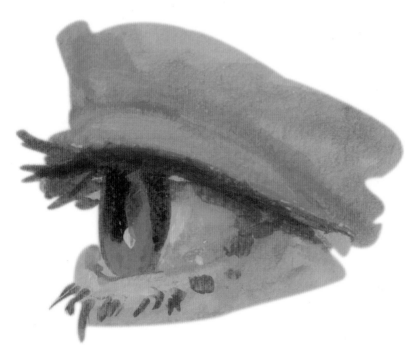

Step 6
Highlight the pupil and iris very subtly with a no. 1 liner. Add some lashes on the bottom, away from the eyelid.

Painting an Older Caucasian Eye

The eyes, irises and pupils are smaller in an older person.

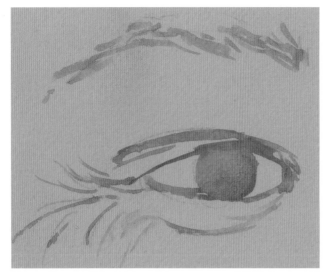

Step 1
Outline the brows, the top of the eye line and lid, the lower lid and the laugh lines and fill in the iris with mix 2 + water. Use the no. 1 liner.

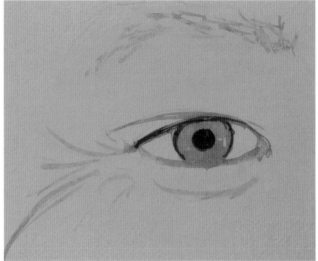

Step 2
Using the no. 6 liner, fill in the skin tone around the eye with mix 1 + water. Dry. Strengthen the eye opening and position the pupil with Prussian Blue + Brown Earth + water on the no. 1 liner.

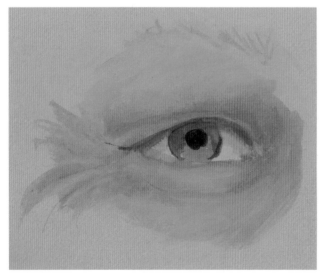

Step 3
Fill in the eyeball area with mix 1 + water on a no. 1 liner. Allow to dry. Shade the eyeball corners and the iris halfway down with Brown Earth + water. Soften. Shade around the eye in the wrinkle areas with mix 2 + mix 3 + Napthol Red Light +Vermilion + a touch of Gold Oxide. Keep soft.

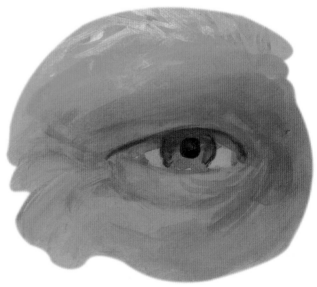

Step 4
With the no. 1 liner, add lighter brows with Titanium White + Yellow Oxide. Continue to deepen the inner corner and concave area, adding more wrinkles with the last mix in Step 3.

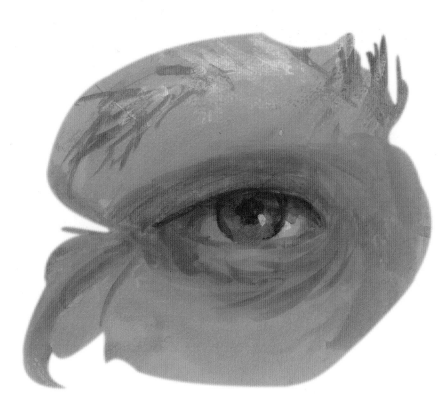

Step 5

Add a few darker areas to the brows with mix 2 + water on the no. 1 liner. Create a light blue mixture of mix 4 + a touch of Prussian Blue and place on the lower iris.

Step 6

If you wish to add glasses, apply the frames with Dioxazine Purple + Norwegian Orange + water on a no. 1 liner. Deepen dark areas within the glasses and eye cavity as necessary. The tiny highlight in the eye is mix 4 + water. Highlight the glasses with Titanium White.

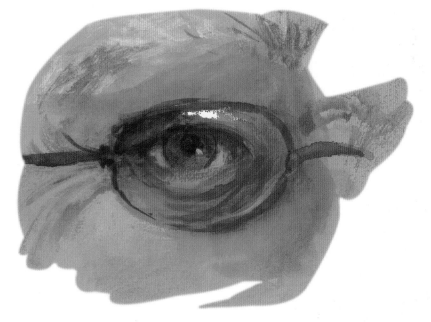

Painting an African-American Eye

Step 1
Establish the eye shape and fill in the iris with Brown Earth + Dioxazine Purple (mix 1 on page 99) + water. Use a no. 1 liner.

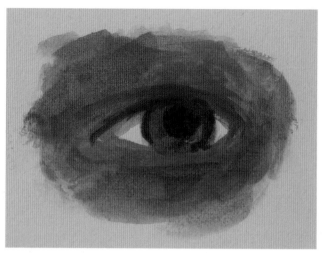

Step 2
Paint around the eye area with a basic flesh mix of Brown Earth + water, using a no. 6 filbert. Place the pupil in and strengthen the sides of the iris and upper lid line with Brown Earth + Ultramarine Blue on a no. 1 liner.

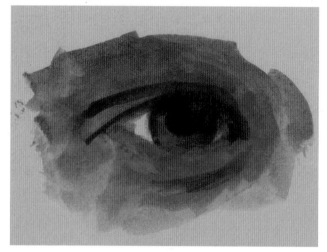

Step 3
Paint the eyeball area with a light blue-gray made from Warm White + Ultramarine Blue + a touch of Cadmium Orange. Allow to dry. Add the shadow from the lid onto the eyeball with Brown Earth + water.

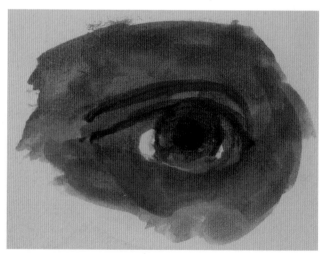

Step 4
Strengthen the eye opening and lid line with Ultramarine Blue + Brown Earth on a no. 1 liner.

Step 5

With the no. 1 liner, add a bit of Burnt Sienna + a touch of Cadmium Orange to the lower iris, and soften. Deepen the eye cavity with Brown Earth + Dioxazine Purple.

Step 6

The brows are a medium-dark blue-gray made from Warm White + Ultramarine Blue + a touch of Cadmium Orange. Add more Ultramarine Blue + a touch of Cadmium Orange for a darker tone. The highlight in the eye is a light gray mix of Ultramarine Blue + a touch of Cadmium Orange + Warm White. Soften. Add a touch of Cadmium Orange + Vermilion to the inner eye corner. The highlight on the face is Burnt Sienna + Amethyst. Lash suggestions are Ultramarine Blue + Brown Earth. Use a no. 1 liner for all of these areas.

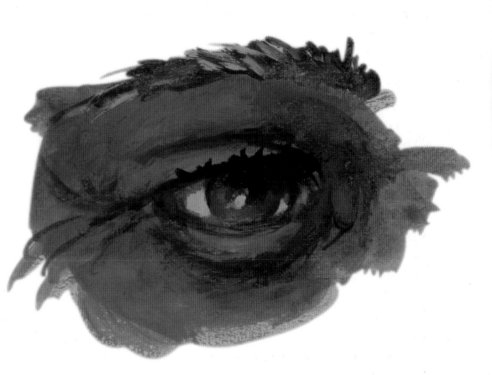

Drawing an Oriental Eye

The shape of the Oriental eye is generally a bit longer and not as wide open as the previous eyes we've done.

The shadows in the inner corners of the eyes will be the same as the other eyes, but shadows on the eyelid will rise above the eyelid near the brow area.

The highlight will catch on the top of the eyelid, making the eyelid appear fuller.

The eyelashes are straighter and usually not seen, except in a three-quarter or side view.

Highlight catches on top of eyelid, making the eyelid appear fuller.

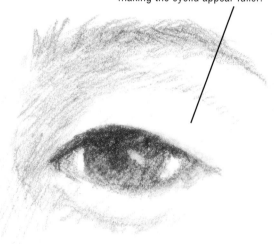

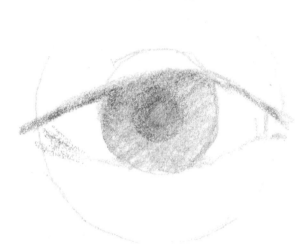

Step 1

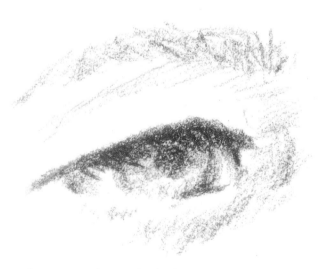

Step 2

Lashes are straighter and only show in the three-quarter or side view.

Painting an Oriental Eye

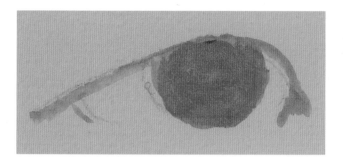

Step 1
Outline the top eye line and fill in the iris with flesh mix 2 (see page 65 or 93) + water on a no. 1 liner.

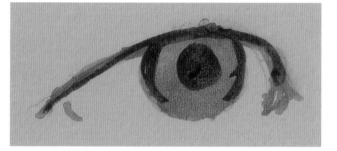

Step 2
Place the pupil in the iris and strengthen the top line with mix 5 + water on a no. 1 liner.

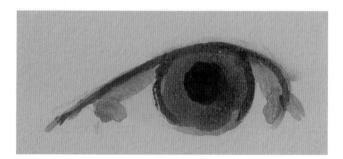

Step 3
Use a light blue made from Warm White + Prussian Blue + a touch of Cadmium Orange in the eyeball area. Allow to dry, then add Brown Earth + water over the entire iris. Shade the eyeball and corners with Brown Earth + water. Use a no. 1 liner.

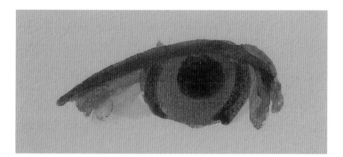

Step 4
Highlight the bottom of the iris with a touch of Burnt Sienna + Gold Oxide + water on a no. 1 liner. Soften.

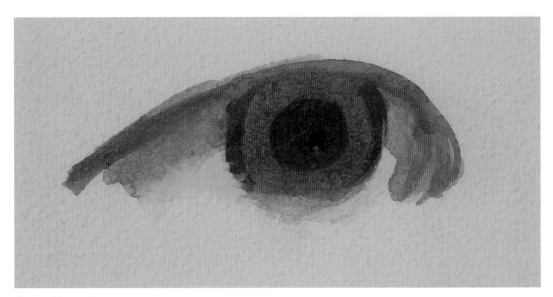

Step 5

Add a bit of Napthol Red Light to the inside corner of
the eye, using a no. 1 liner.

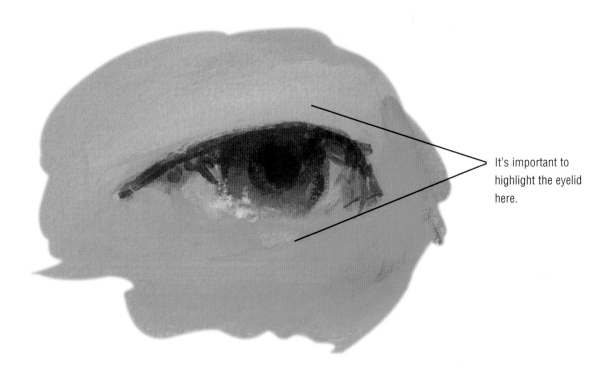

It's important to
highlight the eyelid
here.

Step 6

Strengthen the eye opening with mix 5, and add straight
lashes. Highlight the lower eyelid a bit on the iris with
Warm White + Prussian Blue. Use a no. 1 liner.

Drawing Noses

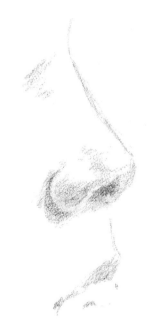

BABY FRONT VIEW

Babies' noses are plump and well rounded. The nostrils may also be round, but they are most often a bit oval, unless the head is tilted back to show the full nostril area. The value or depth of color placed within the nostril area should not be too dark—the color should be a rich, reddish brown tone, leaning more to red. The value should be lessened at the bottom of the nostril, as in the illustration at bottom right.

TODDLER THREE-QUARTER VIEW

This illustration shows a shadow to the left and on the bottom of the nose. This depicts a strong light source coming from the upper right. Note that the nose is slightly tilted up.

TODDLER SIDE VIEW

This side view shows the roundness of the nose, which is tilted upward. The eye sits back from the front of the nose.

YOUNG GIRL SIDE VIEW

This nose is also tilted upward but more of the nostril shows. Note that the nostril fades in intensity at the bottom.

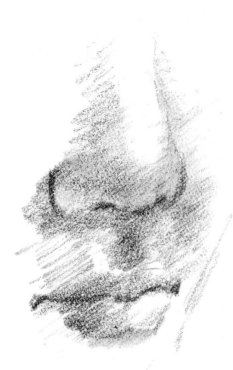

TEENAGER FRONT LEVEL VIEW

Note the oval nostrils and the shadows of the nose and indentation of the upper lip in this illustration.

YOUNG ADULT THREE-QUARTER VIEW

The nostrils here are not round. To maintain the three-quarter view, the center line must always be considered to keep the features in alignment.

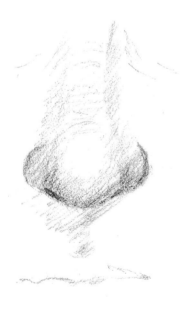

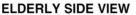

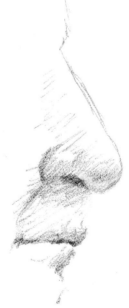

MATURE FRONT VIEW

The nose becomes more pointed and droops a bit, hiding the nostrils.

ELDERLY SIDE VIEW

This nose is tipped down a bit (as we age gravity tends to pull everything downward), and the nostrils may become larger and longer ovals.

ELDERLY SLIGHT THREE-QUARTER VIEW

This nose is beginning to show some signs of age, with the lines on the sides of the nose more prominent and a bit of wrinkling around the mouth.

Drawing Men's Noses

Men's noses are more prominent and angular and tend to have larger nostrils than women's. Men's noses often seem to be the most prominent feature on their faces, showing strength of character.

MATURE MAN THREE-QUARTER VIEW

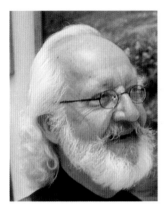

Reference photo.

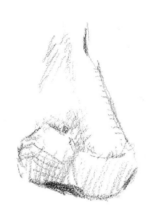

ENLARGED VIEW OF MATURE MAN'S NOSE

This block nose shows how to use shading to show form.

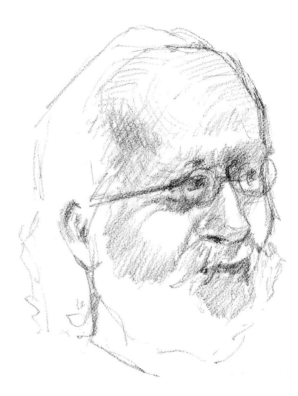

ORIENTAL MAN

This Oriental man is young, so his nose is smaller. Note how his nose spreads as he smiles.

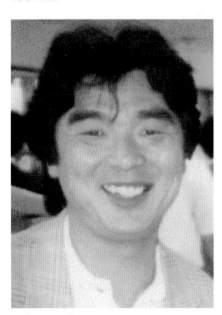

Reference photo.

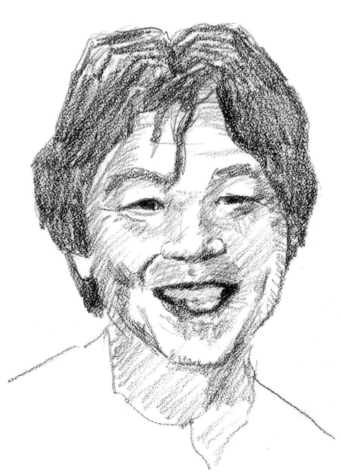

MATURE AFRICAN-AMERICAN
MAN SIDE VIEW

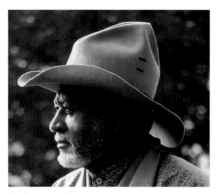

Reference photo.

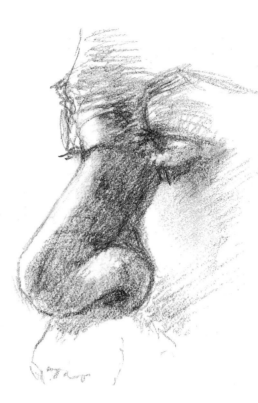

MATURE CAUCASIAN MAN
SIDE VIEW

Note how this nose is larger in size than a woman's.

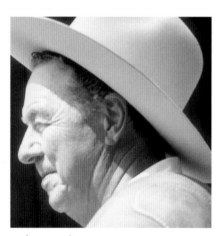

Reference photo.

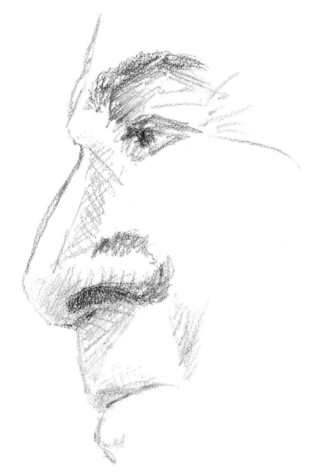

Drawing the Mouth and Lips

The mouth, more than any other feature, is affected by the muscles around it. The lips are seldom still—they swallow, talk, eat—so sometimes their shape can be very elusive. Lips also have many lost and found edges to consider. I find mouths exciting to study and paint.

John Singer Sargent, the famous impressionist portrait painter, commented, "A portrait is a painting of a person where there is something a little wrong with the mouth."

Although you may never render a mouth perfectly, keen observation and study of different views of a person's mouth will enable you to grasp the character of the individual.

Basic Mouth Front Level View

center line lower lip suggestion

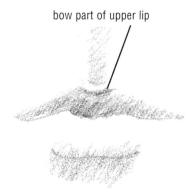

bow part of upper lip

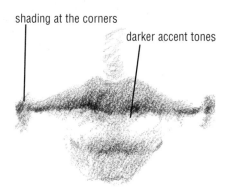

shading at the corners

darker accent tones

Step 1
This is a basic mouth. Begin with the center line, and place a dot at each corner.

Step 2
The upper lip is built upon the center line and is a wide triangle with a downward curve at the top point. The lower lip is fuller and not as wide. The sides are lost edges, and the shadow will catch the lower edge of the lip and shade downward toward the center of the chin.

Step 3
This step shows the shading from the center line up and from the center line down through the center of the lower lip, softening at the side edges. The dots at the corners are now shaded to suggest dimple indentations of the lips as they meet the cheeks.

Side View

Step 1
The side view also has a bit of a dot or crevice at the back of the mouth.

Step 2
The lips are shaded darker from the inside of the mouth and on the bottom of the lower lip.

Full Lips Front Level View

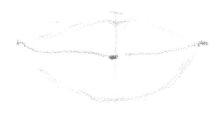 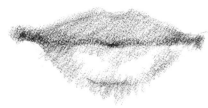 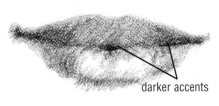

darker accents

Step 1
When sketching fuller lips, start with the center line, then lightly suggest the top and bottom lip.

Step 2
Shade from the center line up to the top. Also shade the corners and the lower lip.

Step 3
Add darker accents to the center. The lips should not be drawn or painted so that they seem to have been outlined with lip pencil. When painting, don't use a color so red it reads as lipstick.

Three-Quarter View

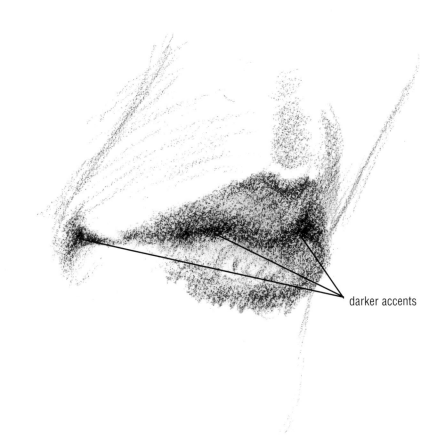

darker accents

Step 1
The center line of the lips is important to ensure your lips read as three-quarter view.

Step 2
Add shading and dark accents.

Another Three-Quarter View

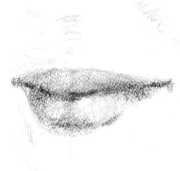

Step 1
Start with horizontal and vertical center lines.

Step 2
Shade the lips up from the center.

Step 3
Accent the darks.

Open Mouth Three-Quarter View

Step 1
This open mouth reveals the teeth, and the view is slightly tilted to three-quarter. Shade inside the mouth.

Step 2
Add more shading on the lips and teeth.

Baby and Toddler Mouths

This page shows views of soft baby and toddler mouths.

Some of these examples have teeth, which should always be grayed down so they are not too prominent. The teeth should also be shaded in the corners to show that they recede into the mouth.

The lips should be more exciting than the teeth, allowing the teeth to be only suggestive.

Painting Teeth

Always paint teeth with a color, not white. Begin with mix 4, and add bits of Ultramarine Blue to achieve a light gray tone.

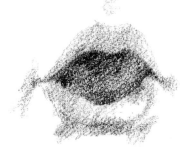

BABY'S MOUTH FRONT VIEW

SMILING MOUTH WITH TEETH

TODDLER'S SMILE

TODDLER'S MOUTH SLIGHT THREE-QUARTER VIEW

BABY'S CLOSED LIPS THREE-QUARTER VIEW

TODDLER'S SMILE WITH THINNER LIPS

Men's Mouths

Not all lips are full, sometimes because of their size but sometimes just because of the way a person holds his or her mouth (for example, if the person is smiling broadly).

The man's mouth will be fuller, again with the upper lip shaded and only a suggestion of the lower lip.

The more mature to elderly mouth will show signs of wrinkles, and the smile line along the cheeks will be much more pronounced.

THREE-QUARTER VIEW

**THREE-QUARTER VIEW
TILTED HEAD**

THREE-QUARTER VIEW SMILE

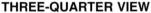

SIDE VIEW

**THREE-QUARTER VIEW
PURSED LIPS**

**THREE-QUARTER VIEW SMILE
WITH STRONG LIGHT SOURCE**

Drawing the Ear

The ears are probably the most difficult element on the head to describe because we don't often look at them. Though the ears are often partially covered by hair, it's important to describe their location accurately. And while we don't necessarily need to depict ears with photo realism, we do need to understand their structure in order to make them look right.

The top of the ear begins approximately at the brow. The lobe of the ear ends approximately along the horizontal line of the nose.

The ears sit at an angle on the head, with the top of the ear nearer the back of the head and the lobe nearer the side plane of the cheek. For this reason, it's important to have the angle of the head and the horizontal lines available for reference.

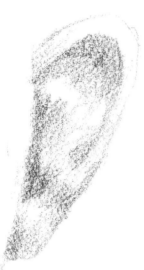

BABY'S EAR FRONT VIEW

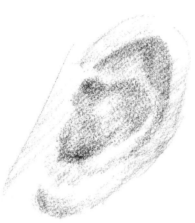

BABY'S EAR SIDE VIEW

BABY'S EAR THREE-QUARTER VIEW

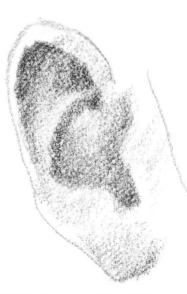

TEENAGE EAR FRONT VIEW

TEENAGE EAR SIDE VIEW

TEENAGE EAR PARTIAL THREE-QUARTER VIEW

BABY THREE-QUARTER VIEW

The top of the ear is above the eye, but below the brow. The bottom of the ear falls at the bottom of the nose.

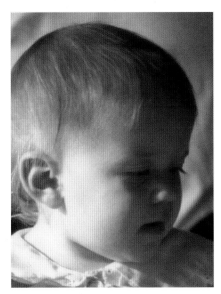

Reference photo.

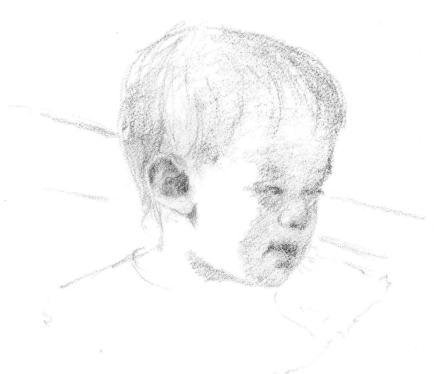

TEENAGER PARTIAL THREE-QUARTER VIEW

Notice the angle of the head. The top of the ear falls above the eye, near the brow. The bottom of the ear falls near the bottom of the nose.

Reference photo.

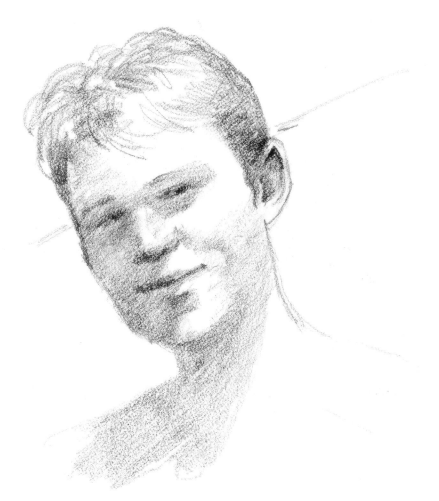

Painting the Ears

Paint the ears with a rich red-orange, keeping the darker areas to a medium-dark value so as not to depict a hole. Use mix 2 deepened with mix 3 in the darkest areas of the ears. I feel it is best to be a bit too light rather than too dark within the ears and nostrils.

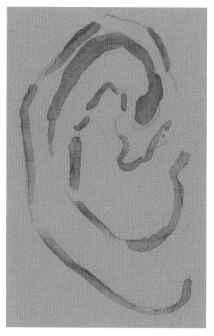

Side View

Step 1
Outline the ear with mix 2 + water on a no. 1 liner.

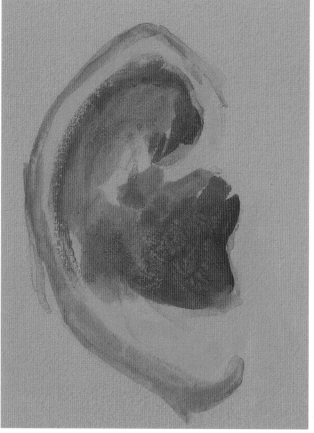

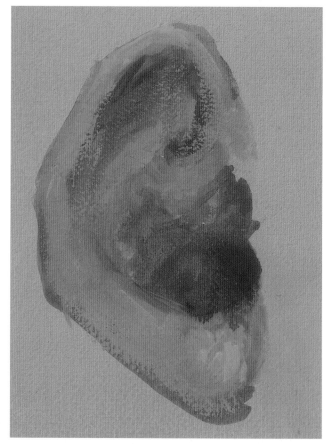

Step 2
Paint mix 1 + water on the light areas, using a no. 6 liner. Deepen the dark areas with mix 2 + mix 3 + more Napthol Red Light + a touch of Vermilion.

Step 3
Using a no. 6 liner, add touches of mix 3 + Napthol Red Light + a touch of Vermilion to the ear where it appears more red.

A Partial Ear

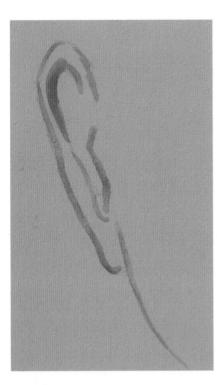

Step 1
Outline the ear with mix 2 + water on a no. 1 liner.

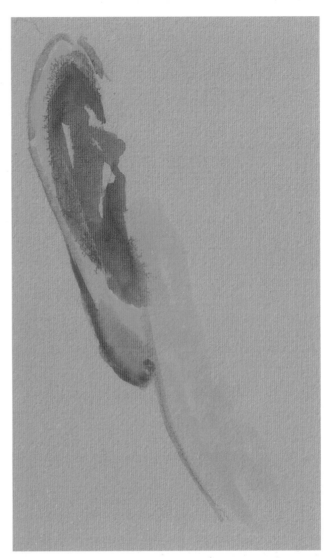

Step 2
Paint mix 1 + water on the light areas using a no. 6 liner. Deepen the dark areas with mix 2 + mix 3 + more Napthol Red Light + a touch of Vermilion.

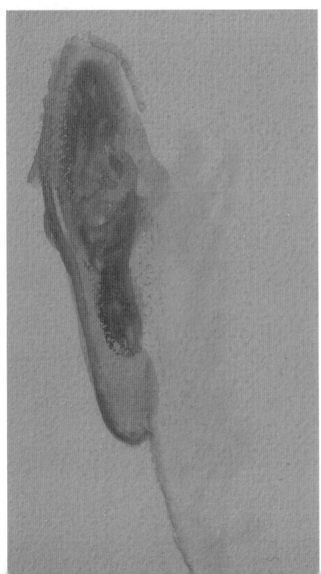

Step 3
Add touches of mix 3 + Napthol Red Light + a touch of Vermilion to the ear where it appears more red. Use a no. 6 liner.

Practice What You've Learned

I've included some reference photos of people of different ages and races for you to practice with. Try your hand at basic placement of the features, then try to draw the features and planes of the face more accurately, referring to the mini-demos in this chapter.

I've also included some of the more complicated head angles, most often seen when people are at their most comfortable and in non-posed positions. Remember to always find the center vertical line first, then proceed to the horizontal and other vertical lines when drawing any of the faces.

PAINTING THE PORTRAIT STEP BY STEP

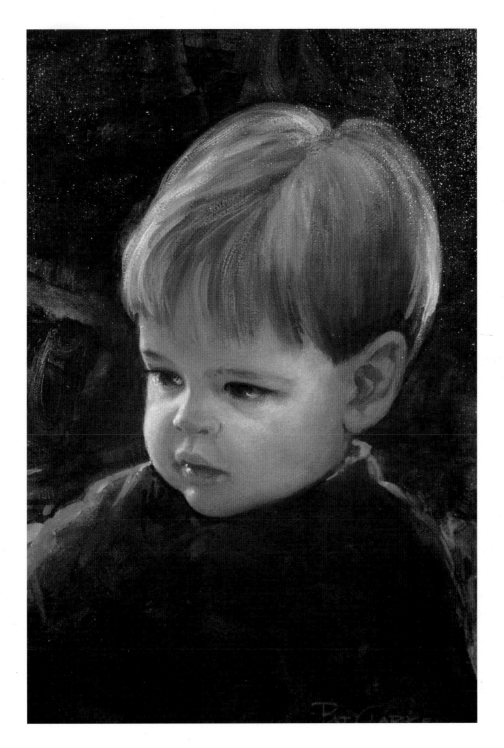

Melody–A Beginning Face Study

This young girl's portrait is three-quarter view and tilted to the right. I've kept the face small and simple, making this a great project for beginners.

I've added some easy lettering and loose, free-form roses to the design to complete this project. If you prefer, you can transfer and paint the portrait without these elements.

Preparing Your Surface

This portrait is painted on a wooden box. Coat the surface with a neutral mixture of 70 percent Dove Grey acrylic + 30 percent glazing medium, applied with a sponge roller. Apply two coats, allowing the surface to dry in between. Leave a bit of texture on the surface.

Trace the pattern onto tracing paper. Slip Super Chacopaper under the tracing paper pattern and transfer a minimum of lines. I suggest transferring only the shape of the hair and face, the line above the eye, the iris and brow suggestions, the nose and nostril suggestions, the center of the mouth, the location of the lower lip and the general clothing shape.

Painting Procedure

To paint any of the portraits in this book, start with applications of half paint + half water. For each additional layer, use more paint and less water.

Continue using paint that is less and less diluted with water until you are ready to paint the blush tone; at this time you will use retarder instead of water, to enhance the open time of the paint when blending is required.

It is important to apply retarder with a dry brush (a brush that has been blotted well to remove excess moisture) and to dress both the surface and the brush you are using with a bit of the retarder. (Please read the section on the use of retarder on page 7.)

It is also important to use a hair dryer to force-dry areas where you've applied retarder and to apply glazing medium to these areas before applying more paint.

Mixtures

Mix 1 Basic Flesh Tone
Titanium White + Gold Oxide

Mix 2 Shading Flesh Tone
Norwegian Orange + Dioxazine Purple + a touch of Gold Oxide

Mix 3 Blush Tone
mix 1 + Napthol Red Light + a touch of Vermilion

Mix 4 Highlight Flesh Tone
Titanium White + a touch of mix 1 + a touch of Cadmium Yellow Mid

Mix 5 Neutral Tone
(Use if the face color needs to be toned down.)
equal parts Amethyst + Moss Green

Materials
Jo Sonja's Artist's Gouache
- Titanium White
- Cadmium Yellow Mid
- Yellow Oxide
- Gold Oxide
- Norwegian Orange
- Vermilion
- Napthol Red Light
- Burgundy
- Dioxazine Purple
- Prussian Blue
- Ultramarine Blue
- Brown Earth
- Amethyst
- Moss Green

Jo Sonja's Artists' Quality Background Color
Dove Grey

Brushes
- no. 6 and no. 8 filberts
- no. 1 liner
- 1-inch (25 mm) flat (for glazing medium)

Surface
9 ¾" x 5" x 2 ¾" (24.8 cm x 12.7 cm x 7 cm) wooden box

Other
- supplies listed on page 8

Painting the Roses and Lettering

After you've completed the portrait, fill in the lettering with Gold Oxide + flow medium. Paint the roses with Burgundy + Napthol Red Light + water, using more Napthol Red Light in some areas and more Burgundy in others. Paint the centers with Burgundy.

Paint the darkest leaves with a mix of Prussian Blue + Gold Oxide. Use a touch of Yellow Oxide + Prussian Blue for the lighter, more intense green tones. Paint the blue-toned leaves with Prussian Blue + Titanium White + a touch of Yellow Oxide.

Paint the scrolls and tendrils with Gold Oxide + water.

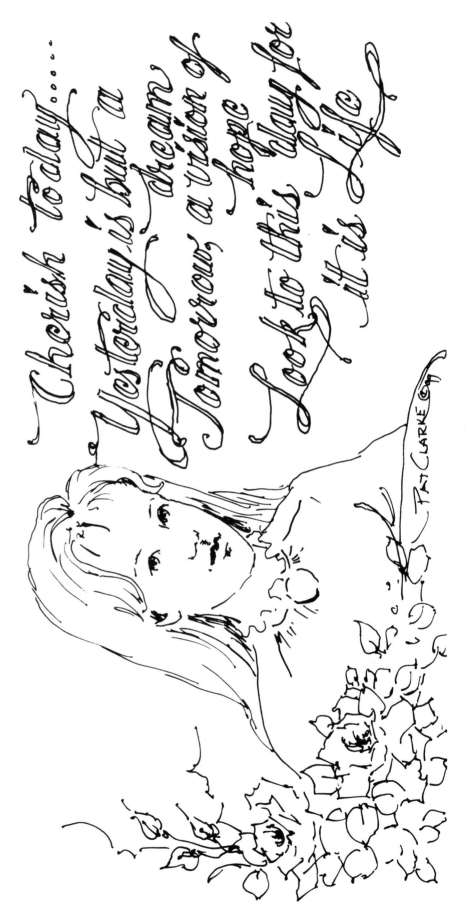

This pattern may be hand-traced or photocopied for personal use only. Shown at full size.

Step 1
Load a no. 1 liner brush with mix 2 + water and lightly outline the main lines of the face, including the features, the upper eyelid, the nose and nostril suggestions and the center line of the mouth. Fill in the entire iris. Dry.

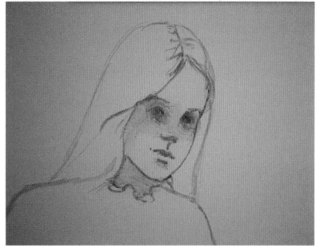

Step 2
Moisten the face with water and stroke lightly to even the water out. With a no. 6 or no. 8 filbert brush, add the concave areas of the eye sockets using mix 2 + a touch of water. Before this paint dries, rinse the brush, blot it and overlap the edge of the area you just painted with the brush bristles. With gentle pressure, soften over the edge of the shadow color to blend it into the background.

Add the side planes, nose shadow and shadow under the lower lip and shade the neck with mix 2 + water on a no. 6 filbert brush, softening all edges.

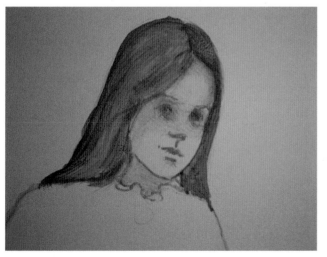

Step 3
Paint the hair with mix 2 + a touch of water. Soften into the face at the hairline, creating a shadow on the forehead. This step keeps the hair from looking like a wig later.

Softening Edges
When softening edges, hold the clean, dry brush high on the handle and use the flat of the brush to skim lightly over the surface at the edge of the darker tone. Like straddling a fence, part of the brush will be on the dark area and part on the light. This creates a medium area, eliminating a hard edge.

When softening edges, it's important not to enter the center of the darkened area; the brush should only touch the edge.

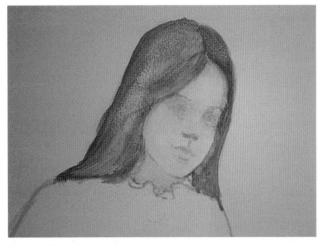

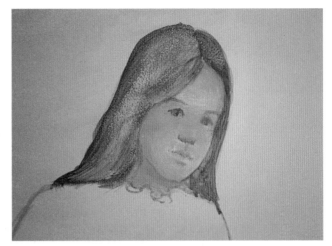

Step 4

Using a no. 6 filbert brush, paint over all areas of the face and neck with a medium-value skin tone made from mix 1 + a touch of mix 2 + a touch of water. Dry. Repaint the the features with mix 2 + water and a no. 1 liner brush. Dry. Paint with glazing medium and dry again.

Step 5

Paint the face with retarder, stroking until it takes on a satiny appearance. While the retarder is still wet, add the blush tone to the cheeks, nose and chin with mix 3 on a no. 6 filbert brush. Soften mix 1 into the blush tone on the left cheek and on the chin, using a no. 6 filbert. Use mix 5 to tone down the blush if it becomes too red.

Add mix 3 + mix 2 to the eye cavities, side planes and neck with a no. 6 filbert. Dry with a hair dryer and paint with glazing medium.

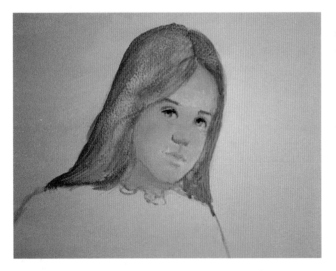

Step 6

Use a no. 1 liner for all areas in this step. Outline the line above the eye, the sides of the iris and from the top of the iris halfway down with Brown Earth + water. Soften the bottom edge of the iris.

Paint the white eyeball area with a pale blue tone made from Titanium White + Ultramarine Blue + a touch of Vermilion. Add a bit more blue to the mix and touch the color to the lower iris. Soften. When dry, add Brown Earth + Ultramarine Blue pupils and soften.

<div style="border:1px solid black; padding:10px;">

Keep Your Paint From Reactivating

Periodically throughout the painting session, dry the paint with a hair dryer to heat set it, then paint with glazing medium to ensure that the paint does not reactivate.

</div>

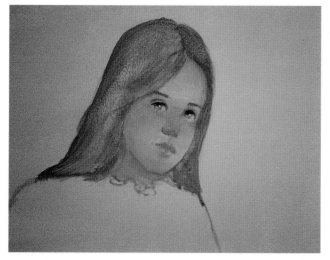

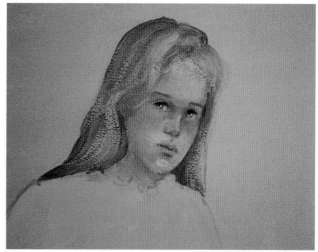

Step 7

Highlight the eyes with a tiny dot of Titanium White + water on a no. 1 liner. Rinse the brush, blot it and soften the highlight. Deepen the blush tone on the cheeks, nose and lips with mix 3 + more Napthol Red Light + a touch of Vermilion, using a no. 6 filbert. Add the nostrils and the center line of the mouth with Burgundy + Brown Earth + water and a no. 1 liner brush. Soften.

Step 8

Use a no. 6 filbert for this step. Add the final highlights with mix 1 + mix 4. Add brighter highlights with mix 4, if needed.

Extend the forehead up a bit farther with mix 1 + mix 3. Add more hair with mix 2. Highlight the hair by dry brushing Gold Oxide + Titanium White + a touch of Dioxazine Purple.

Paint the dress pale blue with Ultramarine Blue + Titanium White + a touch of Vermilion.

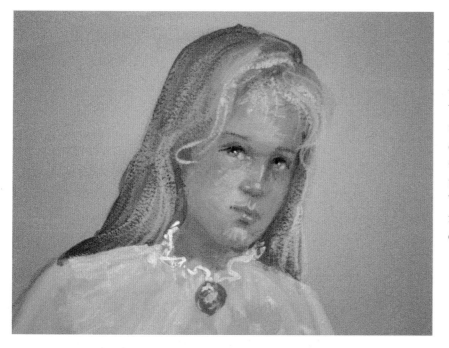

Step 9

Add the final dry brushed highlights to the hair with Titanium White + Yellow Oxide. Highlight the dress with Titanium White + a touch of Yellow Oxide on a no. 6 filbert. Use the no. 1 liner to suggest the collar edge. Paint the broach with Gold Oxide and a no. 1 liner. Highlight the center with Yellow Oxide + Titanium White on a no. 1 liner. Add more blush to the cheeks, nose and chin with a no. 6 filbert, if necessary.

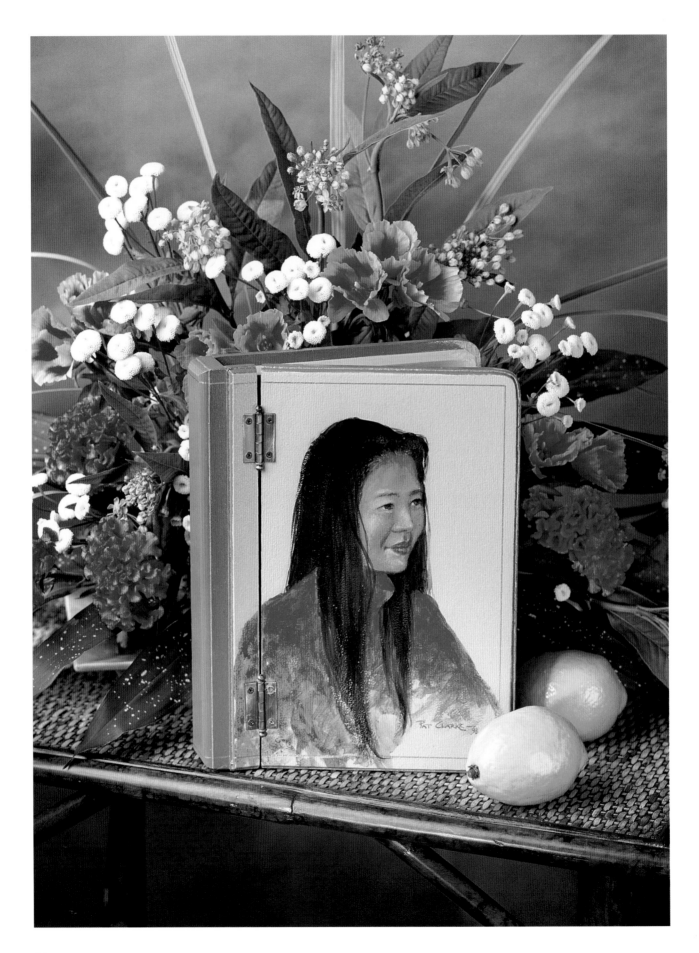

Kiyoko–A Young Japanese Woman

I recently spent a month in Japan, teaching a seven-city seminar tour for Sun-K Co. Kiyoko was my interpreter.

What a delightful girl, and what a wonderful experience, living in a different country and learning about such a different culture. Kiyoko taught me about her country and customs as we visited many ancient temples, castles and beautiful gardens. I shall never forget this great experience.

Oriental Characteristics

Oriental people usually have brown to black-brown hair (unless they use hair color), brown eyes, lovely high cheek bones, full lips, firm chins and slender necks.

The most pronounced difference between Caucasian and Oriental faces are the eyes: Oriental eyes catch light on the eyelid, with no crease showing. This makes the eye seem a bit fuller on top than a Caucasian eye.

The shape of the eye is also not as round, and it is a bit more pointed at each side than a Caucasian eye. The eye can become a touch slanted sometimes, especially when the person is smiling.

Oriental skin tones are more yellow- or olive-complexioned than Caucasian skin tones.

The Japanese people I met were gentle, kind, respectful and sincerely thankful people. What a pleasure to know them—and now to paint them.

Preparing Your Surface

I painted this project on a wooden book box. Prepare the painting surface with one coat of white gesso, then with Dove Grey background color, each applied with a sponge roller to reserve a bit of texture.

Trace the pattern onto tracing paper. Slip Super Chacopaper under the tracing paper pattern and transfer a minimum of lines.

Mixtures

Mix 1 Basic Flesh Tone
Warm White + Raw Sienna + Norwegian Orange + a touch of Dioxazine Purple

Mix 2 Shading Flesh Tone
Dioxazine Purple + Norwegian Orange

Mix 3 Blush Tone
mix 1 + Napthol Red Light

Mix 4 Highlight Flesh Tone
Warm White + Raw Sienna + Napthol Red Light

Mix 5 Dark, Rich Brown-Black Tone
Prussian Blue + Brown Earth + a touch of Purple Madder

Materials
Jo Sonja's Artist's Gouache
- Warm White
- Yellow Oxide
- Raw Sienna
- Gold Oxide
- Norwegian Orange
- Cadmium Orange
- Vermilion
- Napthol Red Light
- Burgundy
- Brilliant Magenta
- Dioxazine Purple
- Purple Madder
- Prussian Blue
- Burnt Sienna
- Brown Earth
- Sap Green
- Amethyst

Jo Sonja's Artists' Quality Background Color
Dove Grey

Brushes
- no. 6 and no. 8 filberts
- no. 1 and no. 6 liners
- 1-inch (25 mm) flat (for glazing medium)

Surface
10½" x 8" x 1¾" (26.7cm x 20.3 x 4.5 cm) wooden book box

Other
supplies listed on page 8

*This pattern may be hand-traced or
photocopied for personal use only.
Shown at full size.*

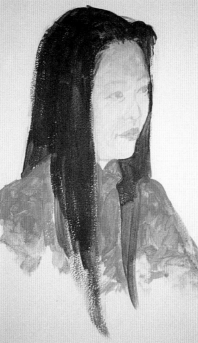

Step 2

Paint the skin areas with mix 1 + water on a no. 6 filbert. Paint the blouse with Brilliant Magenta on a no. 8 filbert. Fill in the hair with mix 5 + a touch of water on a no. 8 filbert. Use a no. 6 filbert where the hair falls over the dress.

Step 1

Outline the face, features and hair with mix 2 + water on a no. 1 liner.

Step 3

Repeat Step 2 until you've developed an opaque coverage; this usually takes two to three coats.

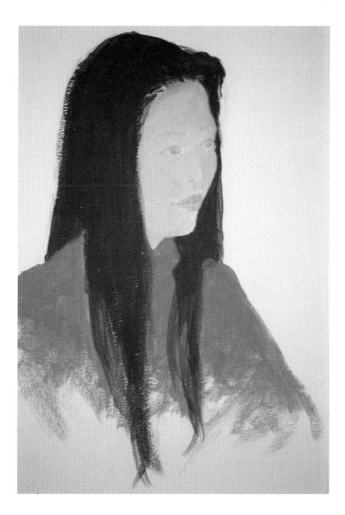

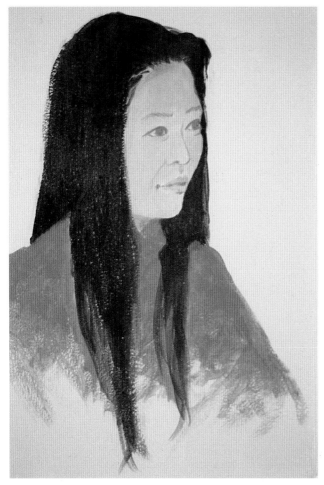

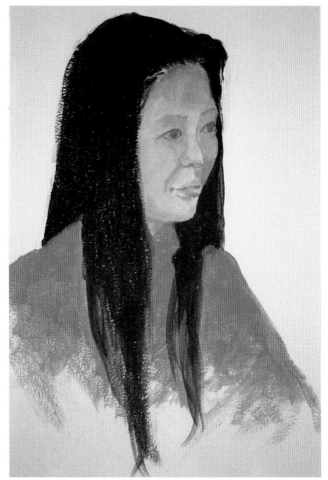

Step 4

Reestablish the features with mix 2 on a no. 1 liner. Dry. Paint with glazing medium, and dry again.

Step 5

Moisten the face with water, and paint the concave and shadow areas of the face with mix 2 + water on a no. 6 filbert, softening the edges. Dry, then apply glazing medium and dry with a hair dryer.

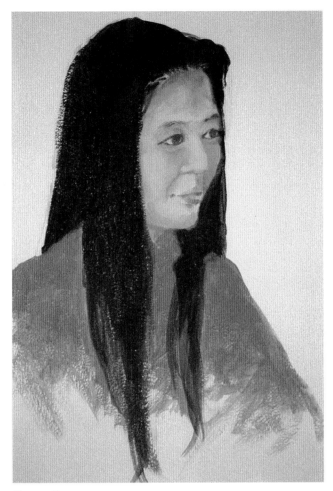

Step 6

Paint the face with retarder. Apply mix 3 to the cheeks, chin and bottom of the nose, using a no. 6 filbert. Use mix 3 + mix 2 to strengthen the shadow areas under the brows, the side plane of the face and the small creases under the eyes. Use a no. 6 filbert. Dry, then apply glazing medium with a 1-inch (25 mm) flat and dry again with a hair dryer.

Step 7

Strengthen the eyes and brows with mix 5 on a no. 1 liner. Add Warm White + Prussian Blue + a touch of Cadmium Orange to the white eyeball areas, using a no. 1 liner.

When dry, coat the face with retarder. Add more mix 3 + a touch of mix 2 to the smile line at the cheeks and chin, using a no. 6 filbert. Move mix 1 into this tone gradually.

Paint the lips with Napthol Red Light + a touch of mix 1 + a touch of Burgundy, using a no. 1 liner. Also add a bit of this tone + water to the underside of the nose and to the cheek area next to the nose on each side. Separate the lips with a no. 1 liner brush and Burgundy + water. Soften. Dry, then apply glazing medium with a 1-inch (25 mm) flat and dry again with a hair dryer.

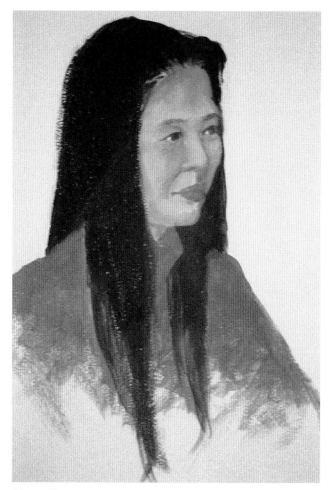

Step 8

Highlight the eyes with Warm White + Prussian Blue + a touch of Cadmium Orange on a no. 1 liner. Add a bit of Napthol Red Light to the inner corner of the left eye with a no. 1 liner. Very subtly suggest the inside of the eyelid on the outer corner of the right eye with Burnt Sienna + Napthol Red Light + water, using a no. 1 liner.

At this point, I also reshaped the right side of the face to make it look more like my reference photo.

Step 9

Skim a lighter tone over the cheeks with mix 1 + a touch of Napthol Red Light on a dry no. 6 filbert brush. Also soften the bottom lid lines. Dry, then apply glazing medium and dry again with a hair dryer.

Apply retarder, then use mix 1 + a touch of Warm White + a touch of Sap Green to highlight the light areas, using a dry no. 6 filbert brush. Be careful not to get too much Sap Green in this mixture—we're only using this color to neutralize a bit of the redness in the cheeks. Soften the edges.

Deepen between the lips with Burgundy on a no. 1 liner, but do not paint a solid line. Also add a bit of Burgundy to the lip edges, and soften. Highlight the lips with mix 3 on a no. 1 liner, and soften.

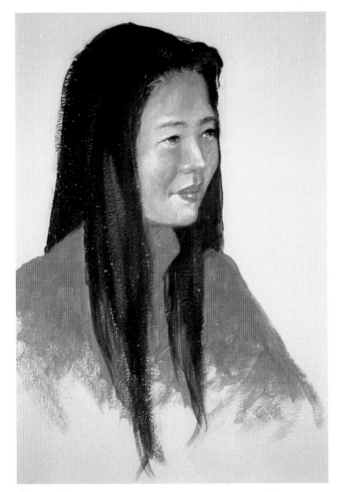

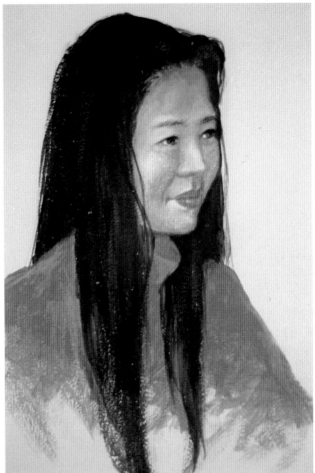

Step 10
Highlight the face further with mix 4 on a no. 1 liner, and soften the edges. Add a touch of Burnt Sienna + Gold Oxide to the lower iris with a no. 1 liner. Re-strengthen the highlight within the eye with Warm White + Prussian Blue, using a no. 1 liner. Dry brush the highlight on the hair with a no. 8 filbert and mix 4 + Warm White + Prussian Blue. Add a reflected light on the temple area, within the eye area and a bit on top of the right eye with Warm White + Prussian Blue + mix 4 on a no. 6 filbert.

Step 11
Soften the highlight in the hair, and add some soft wisps around the face with mix 5 + water. With a no. 6 liner, add a thin wash of Brilliant Magenta + water to the cheeks and chin to create harmony between the face and shirt.

Correcting Shapes
To check for accuracy in your portrait, turn the reference photo and the painting upside down. This allows you to see the subtle shapes of the face without being distracted by your mental image of what each feature should look like. Make any needed corrections with the painting upside down.

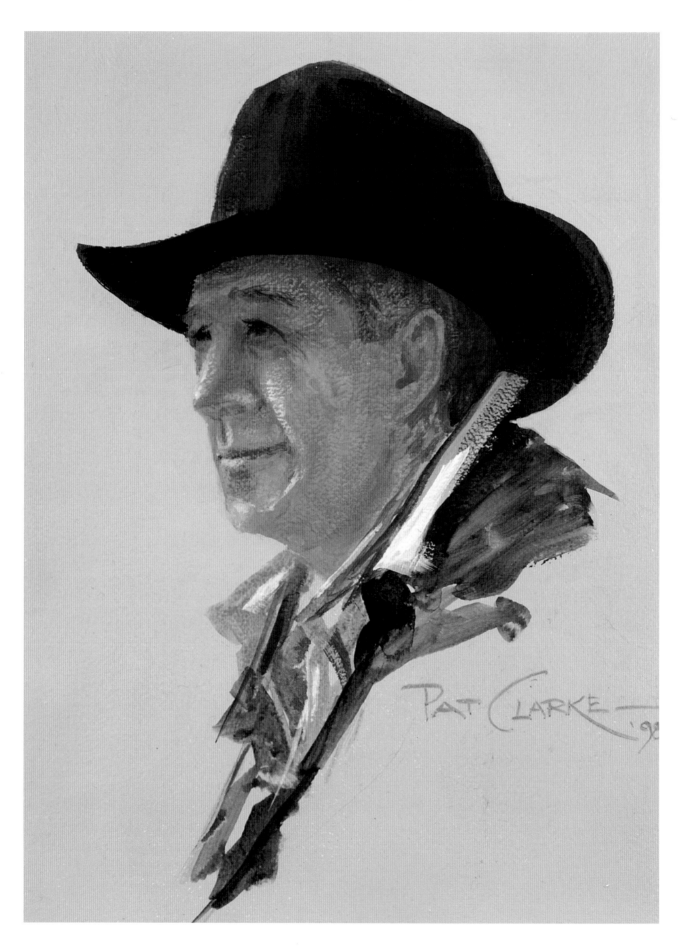

The Cowboy–A Mature Man in a Hat

This three-quarter view portrait is painted on an 8" x 10" (20.3 cm x 25.4 cm) board. The head has a slight tilt.

Preparing Your Surface

Using a sponge roller, coat the surface with white gesso, and allow it to dry. Next, paint the surface with a mid-gray tone of Oakmoss acrylic background paint, applied with a sponge roller.

When painting adult and older people, it is necessary to transfer more of the pattern lines than we've done previously, such as the laugh lines, creases and wrinkles that time has blessed that individual with.

Observe these lines carefully to capture the character and spirit of the portrait. Transfer the pattern with Super Chacopaper.

Working With Values

Building the values gradually from washes to opaque coverage and creating a high contrast of values will allow the focal point of this painting to stand out.

Richness of color is also important. This can be achieved by pushing the colors a bit brighter than you normally do, then neutralizing them in some areas with the complementary color or mix 5, if necessary.

The color mixtures for this project should be deeper in value than usual to achieve the deeper, more rugged complexion of an outdoor person.

Mixtures

Mix 1 Basic Flesh Tone
Titanium White + Gold Oxide + Norwegian Orange

Mix 2 Shading Flesh Tone
Norwegian Orange + Dioxazine Purple + a touch of Gold Oxide

Mix 3 Blush Tone
mix 1 + Napthol Red Light + a touch of Vermilion

Mix 4 Highlight Flesh Tone
Titanium White + a touch of mix 1 + a touch of Cadmium Yellow Mid

Mix 5 Neutral Tone
(Use if the face color needs to be toned down.)
equal parts Amethyst + Moss Green

Acrylic paints dry one to two values darker than they appear when wet, so make allowances for this. If your values become too dark too soon, skim over the dry area with a mid-value dark, allow it to dry, then add a middle-value tone. Many times this can be done with a dry brush. To dry brush, load a brush fully with paint and blot it on a dry paper towel, then lightly skim it over the surface, allowing only minute amounts of color to touch the surface.

Materials
Jo Sonja's Artist's Gouache
- Titanium White
- Cadmium Yellow Mid
- Yellow Oxide
- Gold Oxide
- Norwegian Orange
- Vermilion
- Napthol Red Light
- Burgundy
- Dioxazine Purple
- Prussian Blue
- Ultramarine Blue
- Brown Earth
- Amethyst
- Moss Green
- Carbon Black

Jo Sonja's Artists' Quality Background Color
Oakmoss

Brushes
- no. 8 and no. 12 filberts
- no. 1 and no. 6 liners
- ½-inch (12 mm) and 1-inch (25 mm) flats

Surface
8" x 10" (20.3 cm x 25.4 cm) Masonite board

Other
supplies listed on page 8

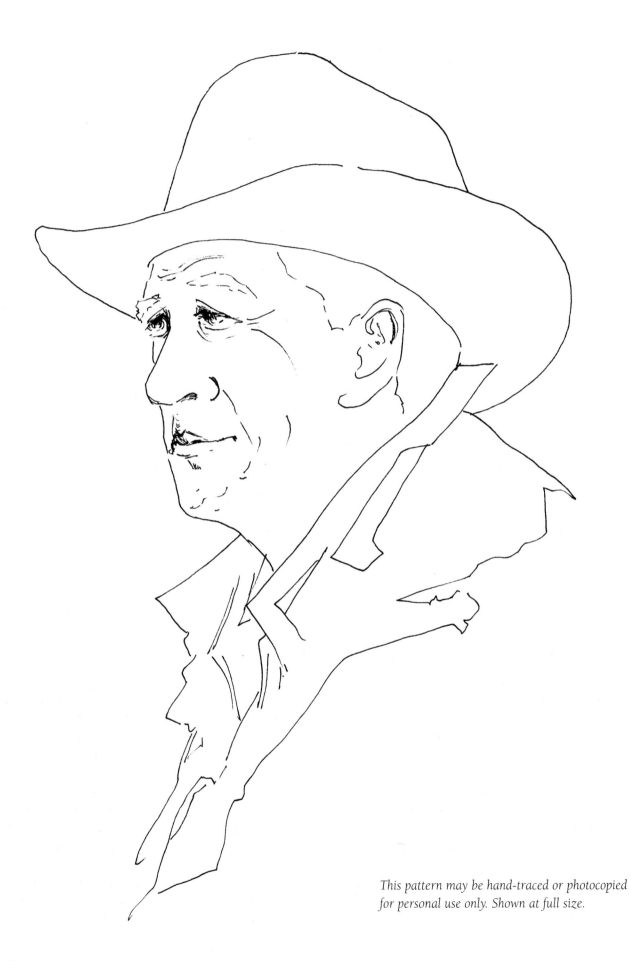

This pattern may be hand-traced or photocopied for personal use only. Shown at full size.

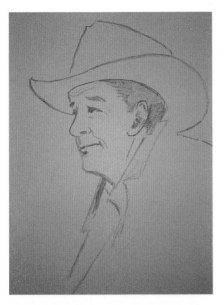

Step 1

With mix 2 + water on a liner brush, outline the major lines of the face (including the wrinkles), the features, the hat and the clothing. Dry.

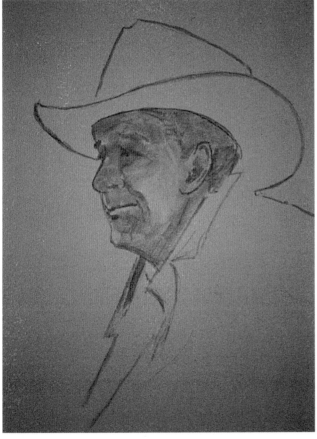

Step 2

Using a no. 12 filbert loaded with mix 2 + water, paint the concave areas of the eyes, the forehead under the hat, in front of the cheek, and on the nose, the chin, under the lower lip and on the neck. Rinse your brush and blot it, then use a touch of water to lessen the value on the right cheek. Dry. Paint over the entire portrait with glazing medium on a 1-inch (25 mm) flat, and dry with a hair dryer.

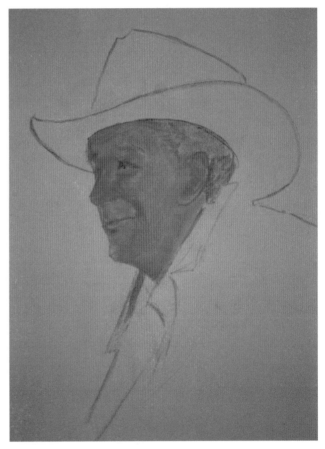

Step 3

Coat the face with retarder, stroke until satiny, then paint mix 1 over all areas, beginning on the right cheek and stretching the paint to the other areas. Use a no. 12 filbert. Do not rinse the brush. While the surface is still wet, pick up more mix 1 + a touch of Ultramarine Blue on the dirty brush and blend into the neck, chin, upper lip under the nose, the right side plane of the cheek and the forehead. Wipe the brush, and soften.

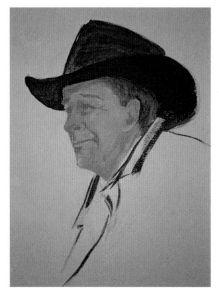 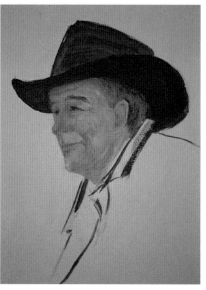 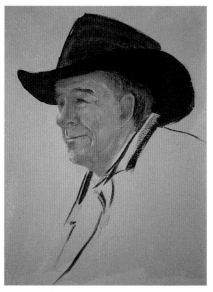

Step 4

Deepen the dark areas of the eyes, brows, inside the ear and other wrinkle lines as necessary with mix 2 on a no. 1 liner. Paint the hair with a dark brown tone of Brown Earth + Prussian Blue. Using a ½-inch (12 mm) flat, paint the hat, beginning on the underside of the brim with Carbon Black + Prussian Blue. The upper part of the hat is not as dark—add a touch of water to the paint for this area. Suggest the coat and collar lines with Carbon Black + Prussian Blue.

Step 5

Strengthen the eyes and brows with a no. 1 liner and Brown Earth + Prussian Blue + water. Use mix 2 + a touch of Napthol Red Light to strengthen the color on the nose, cheeks and lips, adding some occasionally to enhance the wrinkles in the smile lines. Also use this color inside the ear and on the neck and chin. With a no. 12 filbert, add more mix 1 + a touch of Ultramarine Blue to the forehead and side plane on the cheek in front of the ear, fading the color into the neck area.

Step 6

Deepen the shadow area under the nose on the upper lip with mix 2 + more Dioxazine Purple on a no. 1 liner. Soften. Strengthen the nostril and inside the ear with mix 2 + a touch of Burgundy. Begin highlighting with mix 3, alternating with a touch of Yellow Oxide + Titanium White closest to the light. Use a no. 12 filbert. Keep the blush color on the cheeks, nose and chin. Add a touch of Ultramarine Blue + water to the lower part of the iris using a no. 1 liner. Rinse the brush, wipe dry, then soften the blue in the eye.

Keep Your Paint From Reactivating

Remember to periodically force-dry the painting with a hair dryer and to apply glazing medium to ensure that the bottom layers of paint do not reactivate.

"My Portrait Doesn't Look Like the Person I'm Painting!"

Please don't become discouraged if you don't get the results you were hoping for. As in any learning process, our mistakes can teach us a great deal.

Recognizing the reason that something doesn't look right to you is often difficult; in that case, a valued friend might help you evaluate your work.

To target problem areas as you're working, step back from the painting often and view it from a distance; this is how a finished painting is most often seen. Also look at the painting in a mirror or upside down.

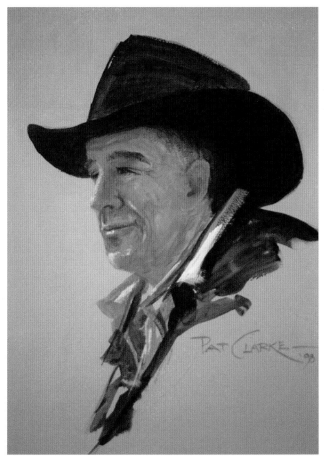

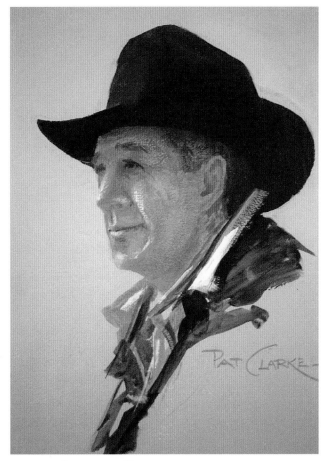

Step 7

Create a blue-gray tone with mix 1 + Ultramarine Blue, and add a bit of this mixture to the hair in front of the ear with a dry no. 12 filbert. Strengthen the center of the mouth with Brown Earth + Burgundy on a no. 1 liner. Wash this color up onto the upper lip, leaving a darker value in the center. If necessary, strengthen the nostril and shadows using mix 2 with more Dioxazine Purple added. Add brow suggestions with Brown Earth + Prussian Blue on a no. 1 liner. Highlight further by dry brushing mix 4 with a no. 6 liner.

Using a no. 12 filbert, add a wash of mix 3 + more Napthol Red Light + Vermilion + water over the ear, nose, chin, lips and cheek. Highlight with mix 4.

Add more Carbon Black + Prussian Blue on the coat and Ultramarine Blue on the shirt collar with a ½-inch (12 mm) flat. Highlight with mix 4 + more Titanium White.

Step 8 (Optional)

At this point, I evaluated my portrait against my reference photo and decided the face was a little off. Since your portrait doesn't have to be an exact likeness of mine, if you are happy with your portrait, you can stop here.

I refined the nose by adding more mix 3 + Napthol Red Light + Vermilion. I also added this color on the cheek, lip and chin. I made the nose highlight stronger and more angular, not so rounded. I strengthened the eye opening and crease lines, adding the pupil again. These are subtle additions, and they need to be addressed slowly and not too strongly at any one time. After these steps, I applied glazing medium and force-dried it.

Next, I refined the wrinkles further with mix 2. I strengthened the eye with Brown Earth + Prussian Blue and added a suggestion of the eyeball with mix 1 + Ultramarine Blue. I added a bit more blush on the bottom of the nose and lips with mix 3 + more Napthol Red Light + Vermilion. I added dark accents on the lips in the center and corners of the mouth with Brown Earth + Burgundy and highlighted with mix 4 as was necessary.

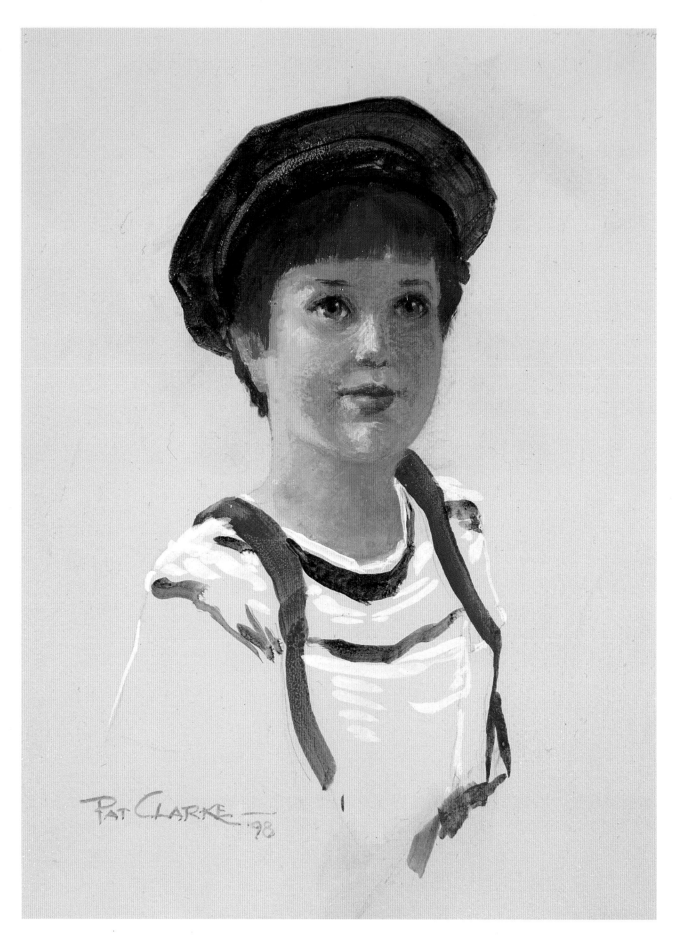

The School Boy—An Adolescent Boy in a Hat

This portrait is painted on a Masonite panel. The head is a level three-quarter view.

Preparing Your Surface

Coat the surface with a neutral tone of 70 percent Dove Grey acrylic + 30 percent glazing medium, applied with a sponge roller. Apply two coats, drying in between.

To transfer the pattern, slip Super Chacopaper under the pattern and transfer a minimum of lines: the shape of the hair and face, the line above the eye, the iris and brow suggestions, the nose and nostril suggestions, the center of the mouth, the location of the lower lip and the clothing. Check the tracing and make any necessary corrections.

Mixtures

Mix 1 Basic Flesh Tone
Titanium White + Gold Oxide

Mix 2 Shading Flesh Tone
Norwegian Orange + Dioxazine Purple + Gold Oxide

Mix 3 Blush Tone
mix 1 + Napthol Red Light + a touch of Vermilion

Mix 4 Highlight Flesh Tone
Titanium White + a touch of mix 1 + a touch of Cadmium Yellow Mid

Mix 5 Neutral Tone
(Use if the face color needs to be toned down.)
equal parts Amethyst + Moss Green

Materials

Jo Sonja's Artist's Gouache
- Titanium White
- Cadmium Yellow Mid
- Yellow Oxide
- Gold Oxide
- Norwegian Orange
- Vermilion
- Napthol Red Light
- Burgundy
- Dioxazine Purple
- Prussian Blue
- Ultramarine Blue
- Brown Earth
- Amethyst
- Moss Green

Jo Sonja's Artists' Quality Background Color
Dove Grey

Brushes
- no. 6 and no. 8 filberts
- no. 1 and no. 6 liners
- no. 6 flat and 1-inch (25 mm) flat (for glazing medium)

Surface
8" x 10" (20.3 cm x 25.4 cm) Masonite board

Other
supplies listed on page 8

This pattern may be hand-traced or photocopied for personal use only. Shown at full size.

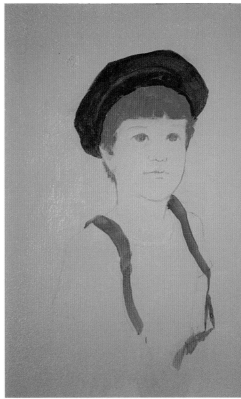

Step 1

Load a no. 1 liner brush with mix 2 + water and lightly outline the main lines of the face, including the features, the upper eyelids, the nose and nostril suggestions and the center line of the mouth. Fill in the entire iris. Dry. Paint the hair with mix 2 + water and a no. 8 filbert. Dry.

Paint the hat with Prussian Blue + a touch of Brown Earth + a touch of water, using the no. 8 filbert. While this is wet, remove a bit of the paint on the edge of the hat bill with the chisel edge of a clean, moistened no. 8 filbert.

Paint the suspenders with Burgundy + water on a no. 6 flat. When this dries, paint glazing medium over all painted areas. Dry.

Step 2

Using the no. 6 filbert, apply mix 1 to the center of the left cheek and stretch the color toward the nose, the side of the face, under the nose and in the upper lip area. Pull the color into these areas until you need to reload the brush. Place the freshly loaded brush in an area of the face that comes toward you, such as the opposite cheek, the nose, the chin or the forehead. Stretch the paint to the other areas to cover the entire face and neck.

Beginning in an area that comes forward each time you reload the brush does two things: It mentally instills those areas that come forward, and it helps you avoid getting crisp edges on the outer and receding areas of the face.

Step 3

Apply another coat of mix 1 + water, as in the previous step. Dry, apply glazing medium and dry again with a hair dryer.

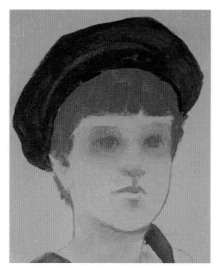

Step 4

Moisten the face with water and stroke lightly to even the water out. With a no. 6 or 8 filbert brush, paint the concave areas of the eyes with mix 2 + a touch of water. Quickly rinse the brush and blot it. While the eye area is still wet, overlap the edge of the shadow color with the dry brush and use gentle pressure to skim over the edges to soften. With mix 2 + water, paint the other concave, shadow and receding areas, such as the side planes of the face, the shadow on the bottom of the nose, the indentation above the upper lip, the upper lip (build this from the center line up to form the bow part of the lip) and the shadow under the lower lip. Switch to the no. 1 liner for smaller areas. Soften all edges. Dry, apply glazing medium and dry with the hair dryer.

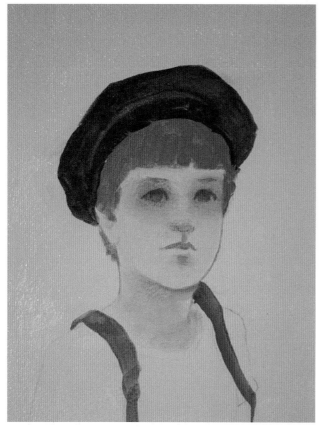

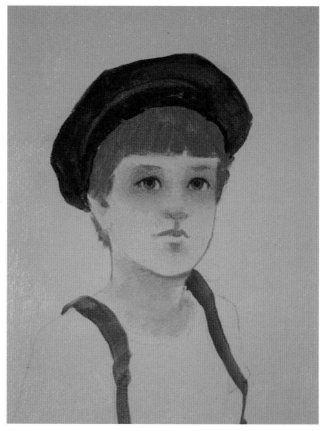

Step 5

Strengthen the eye opening line above the eye and the sides of the iris with Brown Earth + a touch of water on a no. 1 liner. Apply more of this color to the iris from the top to about halfway down. Soften the edge.

Step 6

With a no. 1 liner and Brown Earth + a touch of Prussian Blue + a touch of water, place a round pupil in the center of the iris. Keep in mind that a bit of the iris is covered by the upper lid, so the pupil is closer to the top of the eye. Use a bit more of the above mixture to strengthen the line above the eye and the iris sides. (Do not strengthen the bottom or completely around the iris.) Dry, apply glazing medium and dry again with the hair dryer. Fill in the white areas of the eye with mix 1 on a no. 1 liner. Dry.

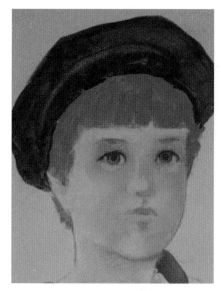

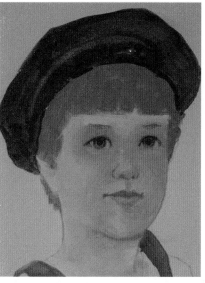

Step 7

Coat the face with retarder. Begin painting the blush areas on the cheeks, nose, chin and entire right side of the face with mix 3, using a no. 6 or no. 8 filbert. Soften mix 1 into the blush tone, always beginning in the light areas and fading into the blush tone. Dry. Apply glazing medium and dry again with a hair dryer.

Step 8

With a no. 1 liner, use Burgundy + Brown Earth to suggest nostrils and the sides of the nose. Soften. Use mix 3 + more Napthol Red Light + a touch of Vermilion to strengthen the blush tones on the cheeks and nose. Carry this color on up into the eye cavities, and wash it over the lower lip. Use a no. 6 filbert. Dry.

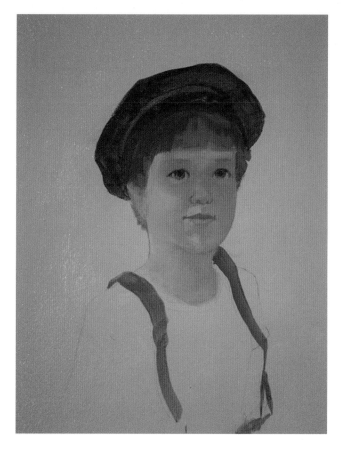

Step 9

Coat the face with retarder. Make a mixture of mix 5 + mix 3 + more Napthol Red Light + a touch of Vermilion. Use this color to paint over all areas on the right—including the forehead, nose and chin—and on the blush or shadow areas on the left side of the face, including the ear. Paint the same mix on the neck, fading into the basic tone on the left. Use a no. 6 filbert. Dry. Apply glazing medium, and dry again with the hair dryer.

Paint the hair next to the hat with Prussian Blue + Brown Earth. Fade this color into mix 2. Paint the ear with mix 3 + more Napthol Red Light + a touch of Vermilion. Dry. Apply glazing medium, and dry again with a hair dryer.

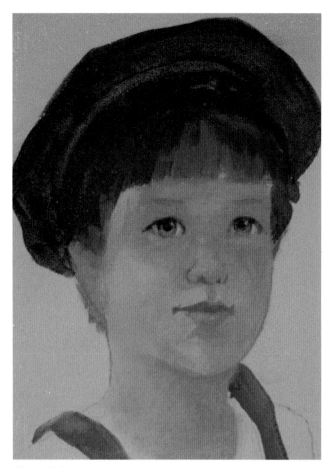

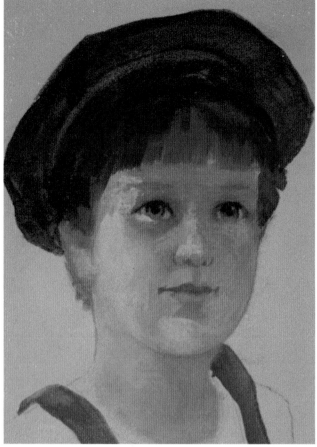

Step 10

Using a no. 1 liner, add a tiny Titanium White + Prussian Blue highlight to the upper right of each iris, connecting the pupil to the iris. Highlight the eyeball area next to the iris with the same mix. Soften.

Step 11

Highlight the light side of the face with mix 1 + mix 4, and soften. Add a bit of mix 3 + mix 1 above the left cheek under the eye. Soften. Add the same mix, but a little darker in value, on the right side under the eye, next to the cheek and on the chin area. This should be subtle.

Step 12

Add more mix 3 to the area between the highlight and the darker blush tone. While this color is still wet, blend it into mix 1. On the bottom and side of the nose, strengthen with more mix 3 + Napthol Red Light + Vermilion. Fade this color into mix 3, adding more as needed to the cheek under the left eye. Dry.

Paint the white stripes in the shirt with Titanium White + water using a no. 6 liner brush. Paint the green stripes with Prussian Blue + Brown Earth.

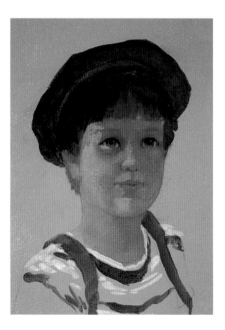

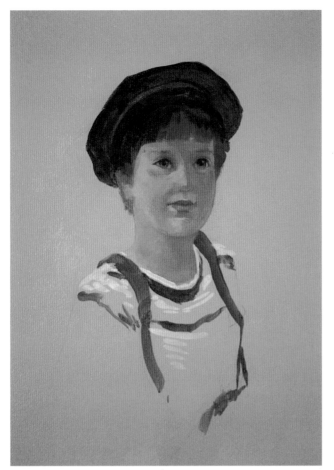

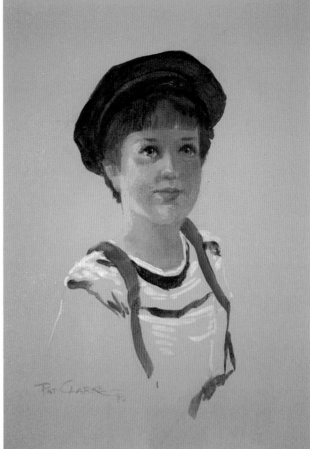

Step 13

Add reflected light to the right side with mix 5. Add more blush to the bottom of the nose, inside the ear and on the right cheek. Add more reflected light—mix 5 + a touch of Prussian Blue—to the forehead, side plane of the face, the right cheek and the chin.

Strengthen the line above the eye with Brown Earth + Prussian Blue, and suggest tiny lashes. Soften.

Step 14

Add more blush to the area in front of the hair on the left and to the nose, cheeks and lips, if needed. Soften. Add stronger highlights to the lightest areas with mix 4, always leaving a bit of the basic value showing between darker and lighter values to create a gentle transition.

Add a stronger highlight within the left eye, connecting the iris and eyeball area, with mix 4 + more Titanium White. Add only a faint highlight on the rim of the right eye with mix 1 + Prussian Blue.

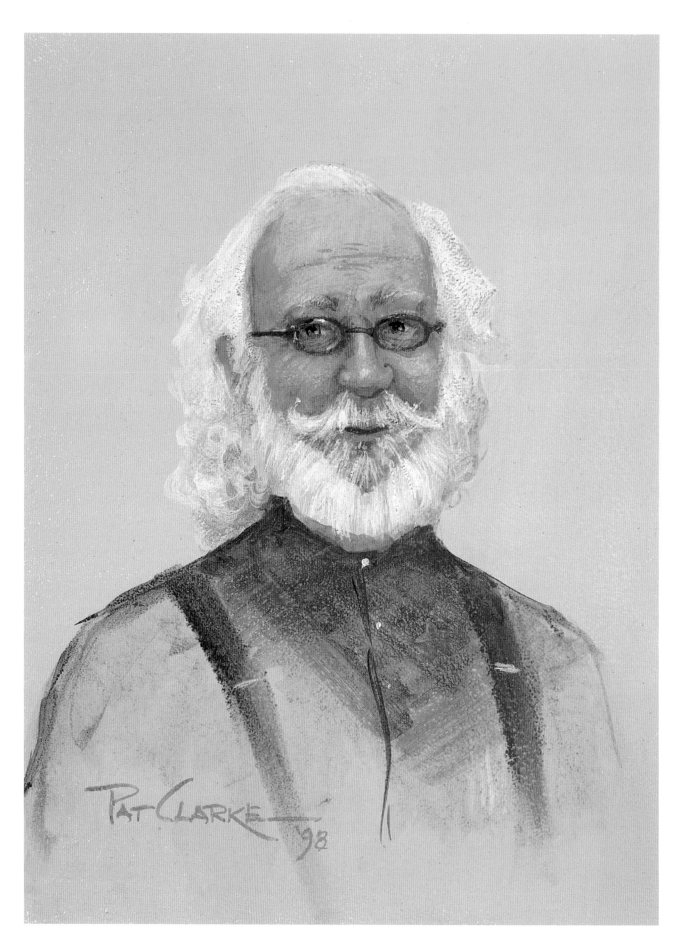

The Artist—An Older Man With Glasses

This portrait is a three-quarter view with a slight tilt to the right. The portrait is painted on an 8" x 10" Masonite panel.

Preparing Your Surface

Coat the surface with gesso. When dry, basecoat with a neutral tone of 70 percent Dove Grey acrylic + 30 percent glazing medium. Apply two coats of this mixture with a sponge roller, drying in between.

When transferring the pattern, you will need to transfer a few more lines than on a younger face: the beard and mustache, the shape of the hair and face, the line above the eyes, the iris and brow suggestions, the nose and nostril suggestions, the center of the mouth and location of the lower lip and the clothing shapes. Omit the lines of the glasses at this time.

Mixtures

Mix 1 Basic Flesh Tone
Titanium White + Gold Oxide

Mix 2 Shading Flesh Tone
Norwegian Orange + Dioxazine Purple + a touch of Gold Oxide

Mix 3 Blush Tone
mix 1 + Napthol Red Light + a touch of Vermilion

Mix 4 Highlight Flesh Tone
Titanium White + a touch of mix 1 + a touch of Cadmium Yellow Mid

Mix 5 Neutral Tone
(Use if the face color needs to be toned down.)
equal parts Amethyst + Moss Green

Materials

Jo Sonja's Artist's Gouache
- Titanium White
- Cadmium Yellow Mid
- Yellow Oxide
- Gold Oxide
- Norwegian Orange
- Vermilion
- Napthol Red Light
- Burgundy
- Dioxazine Purple
- Prussian Blue
- Ultramarine Blue
- Brown Earth
- Amethyst
- Moss Green

Jo Sonja's Artists' Quality Background Color
Dove Grey

Brushes
- no. 6, no. 8 and no. 12 filberts
- no. 1 liner
- no. 6 and ½-inch (12 mm) flat

Surface
8" x 10" (20.3 cm x 25.4 cm) Masonite board

Other
supplies listed on page 8

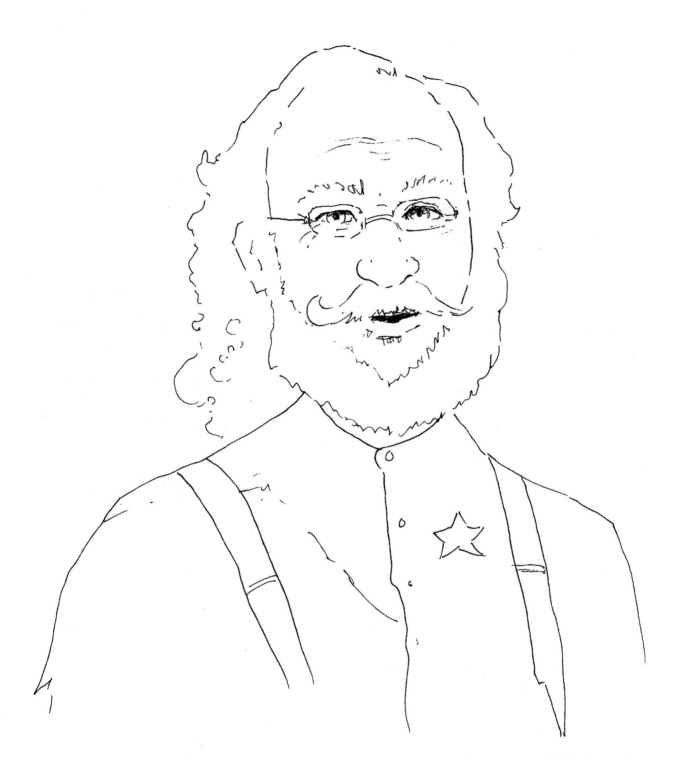

This pattern may be hand-traced or photocopied for personal use only. Shown at full size.

 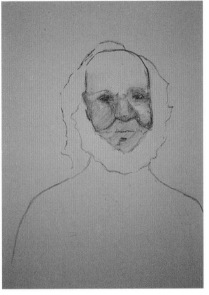 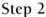 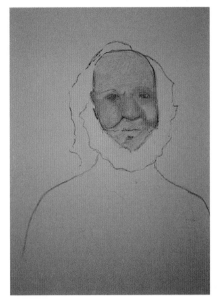

Step 1

Load a no. 1 liner brush with mix 2 + water and lightly outline the main lines of the face, including the features, the upper eyelids, the nose and nostril suggestions and the center line of the mouth. Fill in the entire iris. Dry.

Step 2

Moisten the face with water and stroke lightly to even the water out. With a no. 6 or 8 filbert brush, add the concave areas of the eyes with mix 2 + a touch of water. Quickly rinse the brush and blot it. While the eye area is still wet, overlap the edge of the shadow color with the dry brush and use gentle pressure to soften the outer edges. Add the side planes of the face, the nose shadow and shadow areas on the cheeks and shade in the mustache area and under the lower lip with mix 2 + water, softening all edges. Dry. Apply glazing medium, and dry again with a hair dryer.

Step 3

Beginning on the forehead, base the face with mix 1 + a touch of water, using a no. 6 filbert. Stretch this color into the side planes and edges of the face. Reload with this mix and begin in the cheek area, stretching to cover all areas except the mustache, hair and beard.

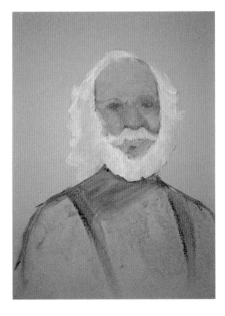

Step 4

Stroke in the hair, beard and mustache with a pale blue-gray tone made from Titanium White + Ultramarine Blue + a touch of Vermilion. Use a no. 6 filbert. With a ½-inch (12 mm) flat, wet the clothing area with water. Add a heavy wash of Dioxazine Purple on the shirt, allowing it to drip and fade to a lighter tone at the bottom. Dry. Add suggestions of suspenders with Dioxazine Purple + a touch of water on a no. 6 flat. With a ½-inch (12mm) flat, stroke a heavier amount of Dioxazine Purple under the beard as a shadow, and soften. Dry.

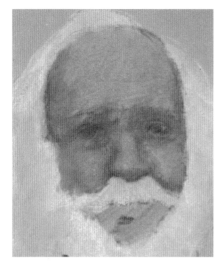 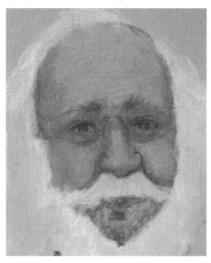 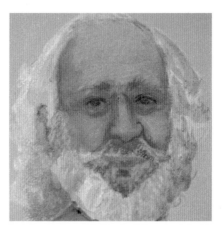

Step 5

Using a no. 6 filbert, coat the face with retarder, stroking until satiny. With mix 2 + a touch more Gold Oxide + mix 3, paint the side planes of the face, the eye cavities, the nose and the lower cheeks. Keep the tone very soft. Dry, apply glazing medium and dry again with a hair dryer.

Step 6

Using mix 2 + water and a no. 1 liner, define the eyes and iris and add a suggestion of fuller brows at the beginning of each brow line above the eyes. Also define the nose, the mouth, the creases on the laugh lines and the pocket under the eyes. Make the chin a bit more angular in the center. Soften.

Step 7

Using a mid-value blue-gray tone of Titanium White + Ultramarine Blue + a touch of Vermilion, paint the moustache with a no. 6 liner. Deepen the value of this mixture and paint the darker areas of the beard and hair. When dry, add a suggestion of an ear on the left with mix 2 + mix 3 on a no. 6 filbert. Paint the lips with mix 3 + water on a no. 1 liner.

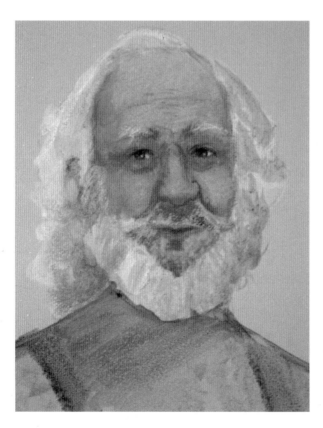

Step 8

Using a no. 1 liner, add a pupil in each eye with Brown Earth + Prussian Blue + a touch of water, keeping this tone very soft—it will dry darker. Separate the lips with Burgundy + Brown Earth + a touch of water. Add lighter brow suggestions with Titanium White + Yellow Oxide + water. Add the whites of the eye with mix 1. Add the highlights with mix 4 + a touch of mix 1.

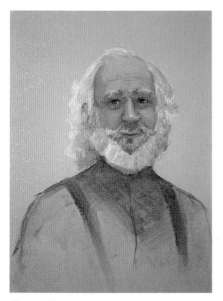

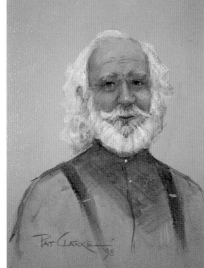

Step 9

With a no. 6 filbert, suggest a bit of neck under the beard with mix 1. Strengthen the shirt color with Dioxazine Purple + a touch of Norwegian Orange + a touch of water. Use a ½-inch (12 mm) flat. Strengthen the tone on the suspenders with a red-violet tone made from Dioxazine Purple + Titanium White + Napthol Red Light.

Using a no. 6 filbert, strengthen the blush areas on the cheeks, nose and lips with mix 3 + more Napthol Red Light + Vermilion. When dry, apply glazing medium and dry again with a hair dryer.

Add a highlight to the nose with mix 1 + mix 4, then mix 4 alone.

Step 10

With a no. 6 filbert, dry brush highlights in the hair, mustache and beard with Titanium White + Yellow Oxide. Dry. Define the creases and wrinkles around the eyes with mix 2 + water on a no. 1 liner. Highlight between the creases with mix 3 on a dry no. 6 liner. Dry brush the nose, cheeks and forehead with mix 1 + mix 4. Highlight the buckles with the gray beard mix above, then lighten further with more Titanium White. Suggest the buttons with Titanium White + a touch of Yellow Oxide. Paint the star with a no. 6 liner loaded with Prussian Blue + a touch of Brown Earth + a touch of Titanium White.

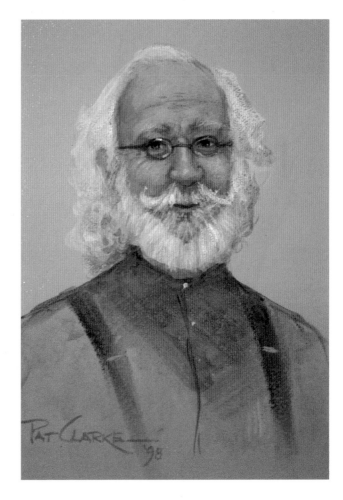

Step 11

Paint the glasses with Dioxazine Purple + a touch of Norwegian Orange + water. Highlight with Titanium White. When the glasses are painted, you will need to deepen the values subtly within the eye cavity areas with mix 2 + mix 3.

Highlight the face further using mix 1 + mix 4 first, then progress to a lighter tone of mix 4. Keep this subtle. Add a touch of mix 3 to the ear. Highlight the hair, beard and mustache with Titanium White.

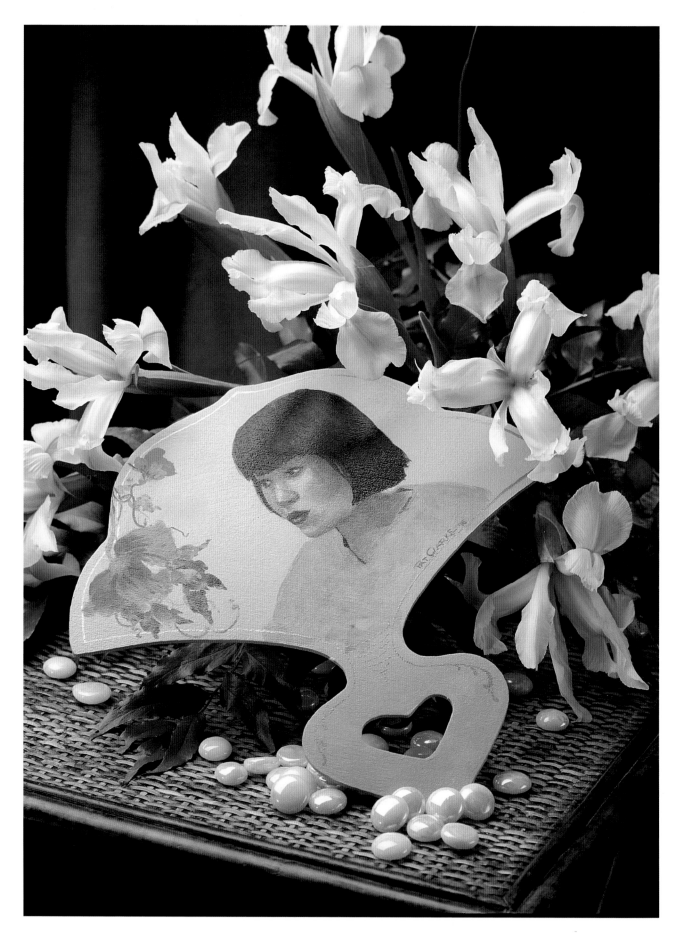

Masako–An Oriental Woman

This woman's beautiful skin and her wonderful, angular bone structure inspired me to paint her portrait. Her skin tone is very pale and cool, and the starkness of her dark hair frames her face beautifully. Note that the color mixtures are different for this woman than for project 2. The view is three-quarter, and her gaze is very intent.

Preparing Your Surface

I painted this portrait on a piece of birch plywood, cut into the shape of a fan. Use the outer pattern lines on page 94 to cut your own fan, if desired. You could also paint this design on a Masonite panel or a wooden box.

Prepare the surface with 70 percent Dove Grey acrylic and 30 percent glazing medium. Use a sponge roller to apply two coats, drying well in between.

I've also included a pattern for the poppies on the back and left side of the fan. You may choose to omit these flowers.

Painting the Poppies

After you have completed the portrait, base the poppy petals with Burgundy + Napthol Red Light + Titanium White. To create variation in the petals, alter this base coat by adding more or less of each of the colors in the mixture.

I used only a little water for the petals in the beginning stage, then thicker paint as I worked to more opaque coverage.

Shade the darker areas with Burgundy + Napthol Red Light, occasionally using a bit of Dioxazine Purple with the mix. Paint the light-

est areas with Titanium White + a touch of Napthol Crimson + a touch of Yellow Oxide.

The centers are dots of Prussian Blue + Brown Earth. Highlight the centers with Prussian Blue + Yellow Oxide.

When the poppies are dry, apply glazing medium over the entire area and dry.

Deepen some dark areas further and suggest a bit of linework within the poppy centers with washes of the shading mixes.

Paint the darkest leaves with Prussian Blue + Gold Oxide + water. Use Prussian Blue + Yellow Oxide for the lightest leaves. Paint the stems and tendrils with one of the green mixes, occasionally using Brown Earth for variety.

Mixtures

Mix 1 Basic Flesh Tone
Warm White + Raw Sienna + a touch of Napthol Red Light

Mix 2 Shading Flesh Tone
Norwegian Orange + Dioxazine Purple

Mix 3 Blush Tone
mix 1 + Napthol Crimson + a touch of Napthol Red Light

Mix 4 Highlight Flesh Tone
Warm White + mix 1 + a touch of Yellow Oxide

Mix 5 Dark, Rich Brown-Black Tone
Prussian Blue + Brown Earth + Purple Madder

Materials

Jo Sonja's Artist's Gouache
- Warm White
- Yellow Oxide
- Raw Sienna
- Norwegian Orange
- Cadmium Orange
- Vermilion
- Napthol Red Light
- Napthol Crimson
- Burgundy
- Dioxazine Purple
- Purple Madder
- Prussian Blue
- Brown Earth
- Amethyst
- Sap Green

Jo Sonja's Artists' Quality Background Color
Dove Grey

Brushes
- no. 6 and no. 8 filberts
- no. 1 liner
- ½-inch (12 mm) flat and 1-inch (25 mm) flat (for glazing medium)

Surface
11½" x 10 ¾" (29.2 cm x 27.3 cm) fan-shaped wooden piece, made from ⅛-inch (.32 cm) thick birch plywood

Other
supplies listed on page 8

Line the outer rim of the fan with a gold pen, maintaining an equal distance from the edge all the way around. Add scrollwork on the handle, if desired.

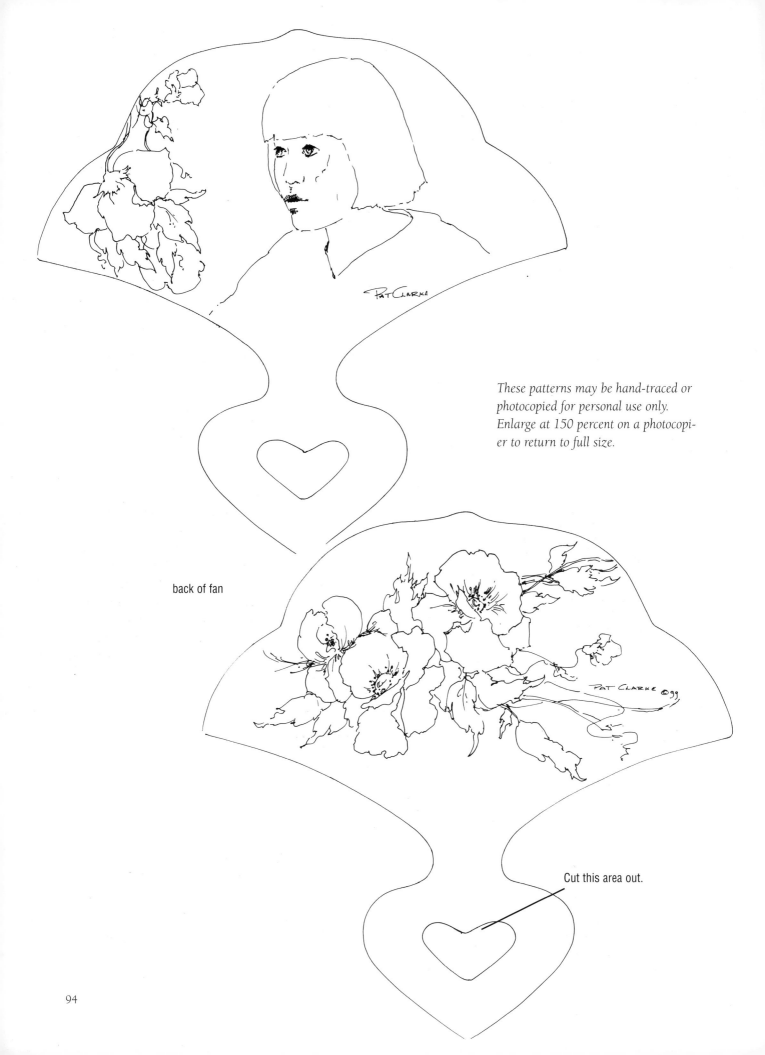

These patterns may be hand-traced or photocopied for personal use only. Enlarge at 150 percent on a photocopier to return to full size.

back of fan

Cut this area out.

Step 1

Outline the face, features and hair with mix 2 + water on a no. 1 liner.

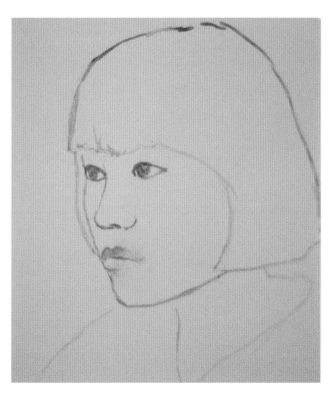

Step 2

Base the face and neck with mix 1 + water on a no. 6 or no. 8 filbert. Base the hair with mix 5 + a touch of water on a ½-inch (12 mm) flat. Paint the shirt with Warm White + Sap Green + a touch of Prussian Blue. Base the face and hair one to two more times, drying thoroughly in between coats. Dry. Paint with glazing medium, and dry again with a hair dryer.

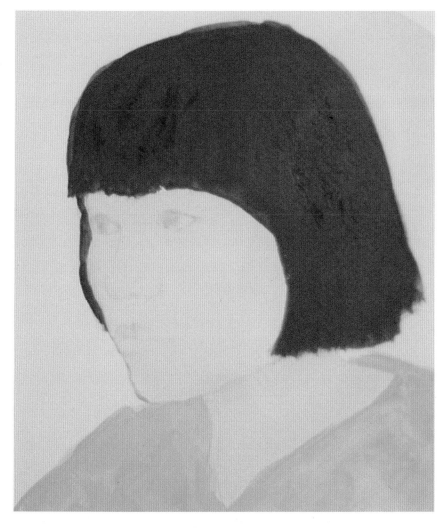

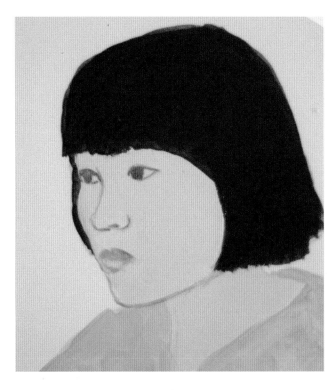

Step 3

With a no. 1 liner, outline the eyes and fill in the iris with Brown Earth + water. Suggest the nose and mouth with mix 2 + water.

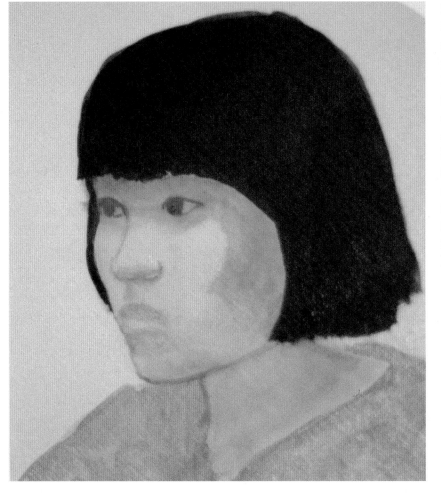

Step 4

Using a no. 6 or no. 8 filbert, moisten the face with water and apply mix 2 + water in the shadow areas, beginning under the hair, down the side plane of the cheek and into the concave eye areas. Soften the edges of each area with a clean, blotted brush so no lines occur. Also place some of this mixture on the bottom of the nose, into the shadow area under the nose, on the upper lip, in the area under the lower lip and on the chin and neck. Use the no. 1 liner in the smaller areas.

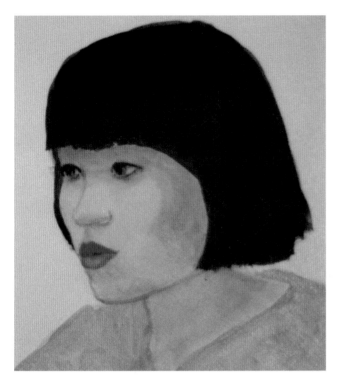

Step 5

Outline the top of the eye opening and add the pupil with mix 5 + water on a no. 1 liner. Dry. Paint the lower lid line with Brown Earth + water. Let this line fall a bit away from the iris to allow some of the basic flesh tone to show, suggesting a lower, fleshy inside lid next to the iris. Soften, then dry. Apply glazing medium, and dry with a hair dryer.

Paint the top lip with Napthol Crimson. Paint the bottom lip with Napthol Red Light + Napthol Crimson. Soften. Separate the lips with Burgundy. Dry.

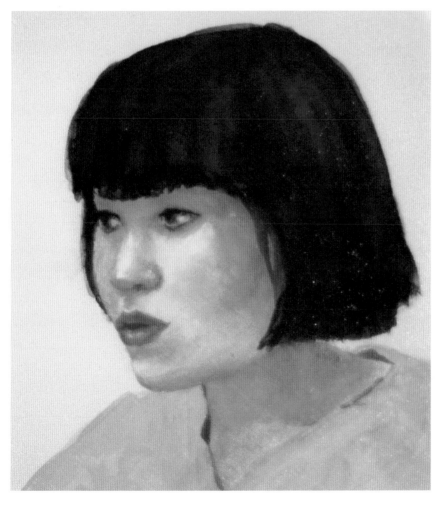

Step 6

Paint the face with retarder. With a no. 6 or no. 8 filbert, apply mix 3 to both cheeks and the chin. On a clean brush, pick up mix 2 + mix 3, and deepen the dark areas on the cheek and neck. Use mix 1 to soften into the blush tone on the front of the cheeks and chin.

Highlight the face with mix 4 and a no. 6 filbert. Paint only the lower area of the white eyeball with mix 1 + a touch of Prussian Blue on a no. 1 liner. Add a touch of Brown Earth + a touch of Cadmium Orange to the lower right side of the iris, and soften. With a dry brush, highlight the hair very subtly with Prussian Blue + Warm White, using a no. 8 filbert.

With a no. 6 filbert, highlight the face further, adding Warm White to mix 4 as necessary. Highlight the lips with mix 3 + mix 4, and soften. Softly highlight the eyeball area with Warm White on a no. 1 liner; keep this very subtle by softening with a moistened brush. Add accent dark areas on the neck next to the sweater with Brown Earth + water on a no. 1 liner.

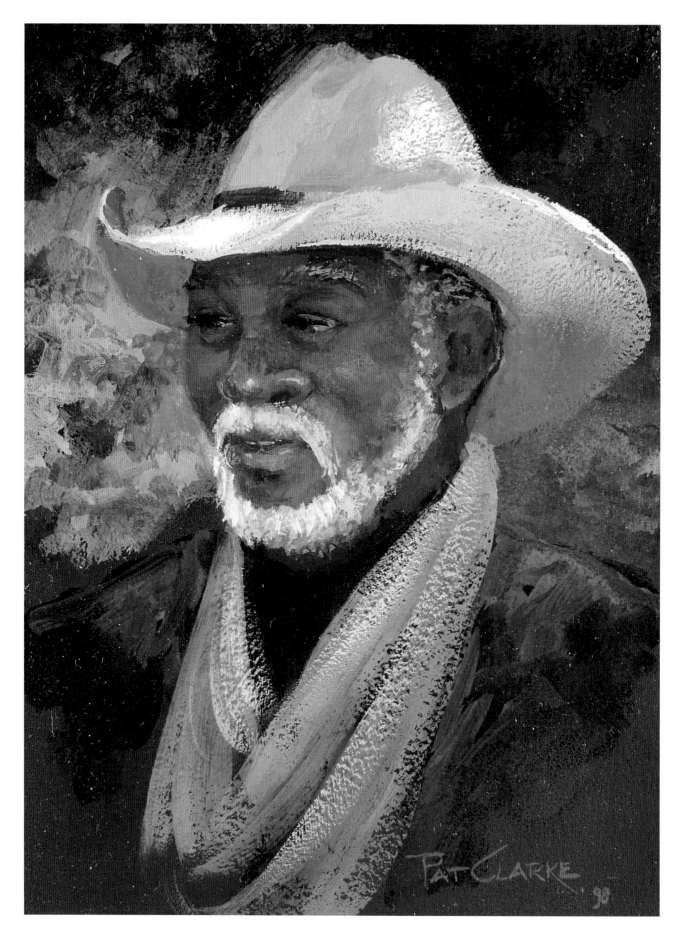

Thomas—An African-American Man

I was so intrigued with this man's face that I did three paintings from the photos I took of him: one three-quarter view in which he is facing to his left, one three-quarter view facing to his right and a full side view. In each portrait the face is level. Note that the cowboy hat casts a shadow on the face and head. The skin tones are beautiful, rich browns, lavenders, greens and blues.

Left-Facing Three-Quarter View

I've included a complete step-by-step demonstration for the left-facing three-quarter view. This portrait is done on a wooden box.

Prepare the top painting area of the wooden box with white gesso, rolled with a sponge roller to leave a bit of texture. When this is dry, use a sponge roller to apply Oakmoss acrylic background color over the gesso. Apply a minimum of pattern lines with Super Chacopaper.

This painting progresses from thin washes of paint to an opaque coverage in the face and hat, which is the focal area.

Side View

Next, I've included an abbreviated demonstration for the side view. This portrait is painted on a small canvas, basecoated with brown gesso.

Starting on a dark background when painting a dark-complexioned portrait is a quick way to begin our portrait, allowing us to use lighter tones to build the face. The tones build to rich colors quickly, with little effort. Highlights are built gradually to an opaque coverage.

It is important to paint those areas surrounding the face early in

the painting so colors will relate properly to one another.

Right-Facing Three-Quarter View

I've also included a pattern for the right-facing view (shown on page 98), which I painted on a Masonite panel. Prepare the Masonite panel with two coats of brown gesso, applied with a sponge roller.

This view can be painted using the instructions for the side view. However, it is important in this study to apply the background early in the painting session so colors will relate to one another.

The trees are painted first with Hookers Green + Ultramarine Blue. Overlay the base color with Hookers Green + Sap Green + a touch of Yellow Oxide. Finally, paint the lightest areas with Hookers Green + Sap Green + Yellow Oxide + Warm White.

Mixtures

Mix 1 Rich, Dark Brown
Brown Earth + Dioxazine Purple

Mix 2 Light Blue-Gray
Warm White + Ultramarine Blue + a touch of Cadmium Orange

Mix 3 Medium Blue-Gray
mix 2 + more Ultramarine Blue + a touch of Cadmium Orange

Mix 4 Darker Blue-Gray
mix 3 + more Ultramarine Blue

Mix 5 Rich, Dark Black
Purple Madder + Hookers Green

Materials
Jo Sonja's Artist's Gouache
- Warm White
- Yellow Oxide
- Raw Sienna
- Cadmium Orange
- Vermilion
- Napthol Red Light
- Dioxazine Purple
- Purple Madder
- Ultramarine Blue
- Brown Earth
- Burnt Sienna
- Hookers Green
- Sap Green
- Amethyst

Jo Sonja's Artists' Quality Background Colors
Oakmoss (left-facing view)

Brushes
- no. 6 and no. 8 filberts
- no. 1 and no. 6 liners
- no. 6, ½-inch (12 mm) and 1-inch (25 mm) flats

Surfaces
- 7" x 7" x 2¾" (17.8 cm x 17.8 cm x 7 cm) wooden box (left-facing view)
- 8" x 10" (20.3 cm x 25.4 cm) canvas (side view)
- 5" x 7" (12.7 cm x 17.8 cm) Masonite panel (right-facing view)

Other
- supplies listed on page 8
- brown gesso

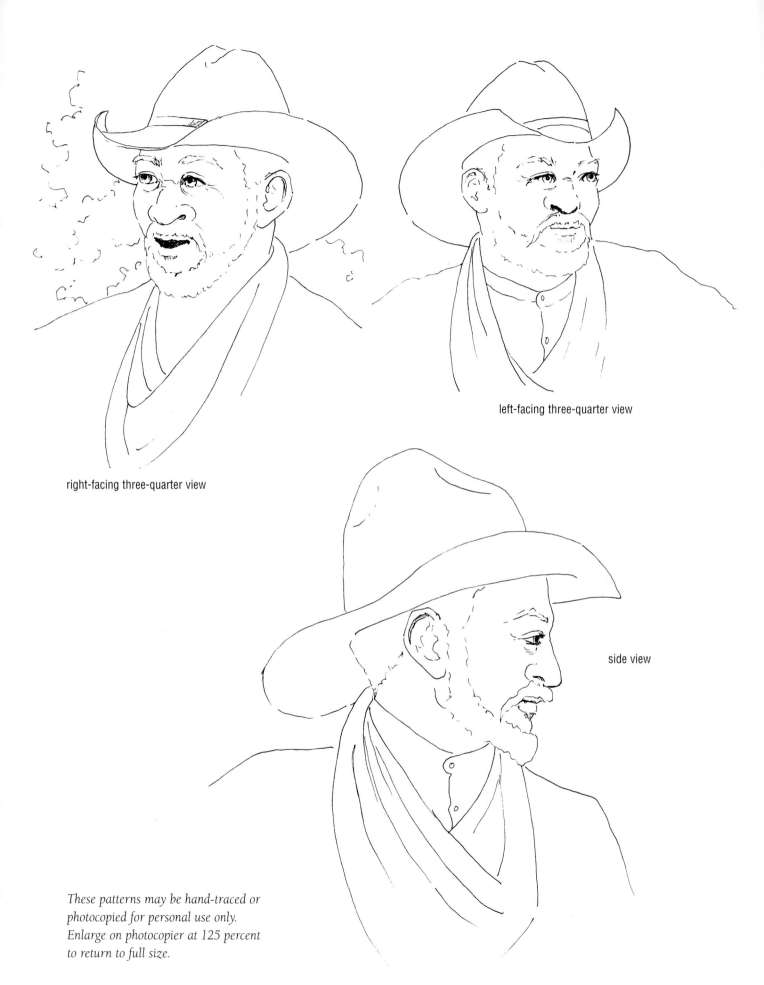

right-facing three-quarter view

left-facing three-quarter view

side view

These patterns may be hand-traced or photocopied for personal use only. Enlarge on photocopier at 125 percent to return to full size.

Left-Facing Three-Quarter View

Step 1
Outline the face and features with mix 1 + water to hold the pattern lines, using a no. 1 liner.

Step 2
Base the face, neck and ear with Brown Earth + water on a no. 6 filbert.

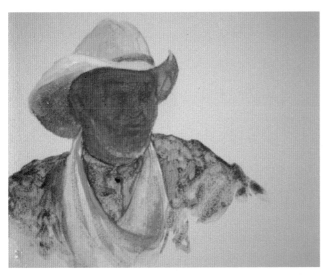

Step 3
Shade the hat with a neutral blue tone of Ultramarine Blue + a touch of Cadmium Orange + Warm White on a ½-inch (12 mm) flat. Paint the light area with a medium-value mix of Warm White + Yellow Oxide + the shading mix from above. Paint the neckerchief with the hat shading mix + a touch of Hookers Green + water, allowing the background to show through. Paint the shirt with Hookers Green + Ultramarine Blue + water, still using the flat brush. Coat the face again with Brown Earth + a touch of water on a no. 6 filbert. When dry, coat the face with glazing medium and dry.

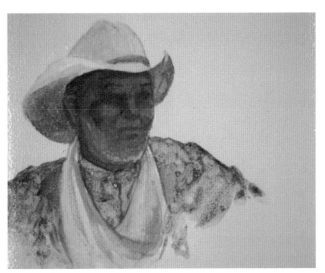

Step 4
With a no. 6 filbert, apply mix 1 + water in the dark shaded areas of the eye cavities, shadow under the hat, the side planes of the head, the cheek and the nose. Also use this mix to paint the center of the mouth and the upper lip and the shading under the lower lip and on the neck. Use a no 1 liner. Dry, paint with glazing medium and dry again.

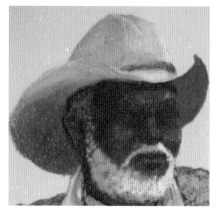 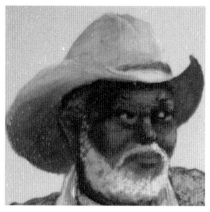 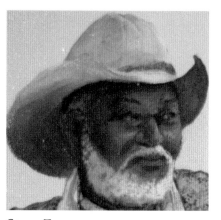

Step 5

Begin painting the lightest areas of the mustache and beard (the right side) with mix 3 + a touch of water on a no. 6 liner. Use mix 2 + a touch of mix 3 in the medium area of the mustache and beard. Add a bit more of mix 3 to the above mix for the darkest areas, working with a dirty brush from the previous color. Suggest the eyebrows with the same color and a no. 1 liner. Reinforce the eye shape and iris, the dark nostril area on the left and a few eyebrow hairs within the gray area using Brown Earth + Ultramarine Blue. Dry, paint with glazing medium and dry again with a hair dryer.

Step 6

Paint the white eyeball areas with mix 3 + a touch of mix 2 on a no. 1 liner. Paint the face with retarder and begin highlighting the light areas on the nose, cheeks, forehead, under the eyes and on the chin with Burnt Sienna + Amethyst on a no. 6 filbert. Soften. Paint the lips with Napthol Red Light + Warm White + a touch of Burnt Sienna, using a no. 1 liner. Dry with a hair dryer, paint with glazing medium and dry again.

Step 7

Paint with retarder. Strengthen the dark side planes of the head, cheek and nose with Purple Madder + Brown Earth on a no. 6 filbert. Highlight again with Burnt Sienna + Amethyst. Soften. Add a touch of Burnt Sienna + a touch of Cadmium Orange to the lower iris, and soften on a no. 1 liner. Strengthen the eye opening and brows with Brown Earth + Ultramarine Blue. Dry with a hair dryer, apply glazing medium and dry again.

Step 8

Fine-tune the light areas with Raw Sienna + Burnt Sienna + Amethyst. Refine the darks on the side planes with Purple Madder + Brown Earth as needed. Dry, apply glazing medium and dry again.

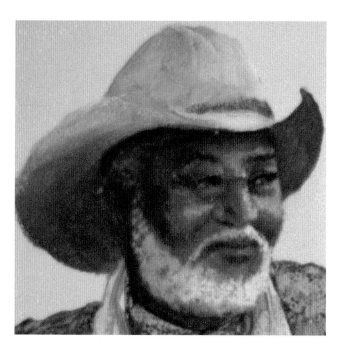

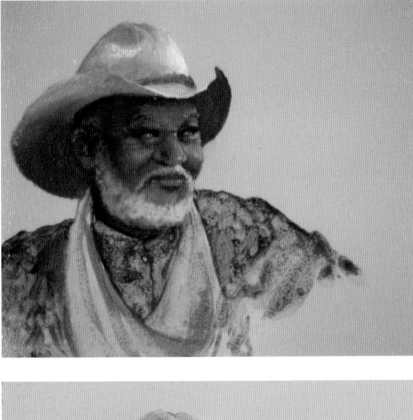

Step 9

Use a no. 6 filbert for larger areas and a no. 1 liner for smaller areas. Highlight the hat with mix 2 + more Warm White + a touch of Yellow Oxide.

Add a wash of Burnt Sienna + water over the face. Paint the lips with Napthol Red Light + Burnt Sienna + a touch of Warm White. Also add touches of this color to the ear, lower cheeks and nose.

Highlight the face with Burnt Sienna + Amethyst + Warm White + a touch of Napthol Red Light. Highlight the eyes with mix 2 + more Warm White + a touch of Ultramarine Blue.

Add more hair to the eyebrows with mix 2. Soften the side planes of the face with Burnt Sienna + a touch of Amethyst + Ultramarine Blue + water on a dry brush. Soften.

Deepen the shaded areas on the hat next to the face and head with Hookers Green + Ultramarine Blue + water. Soften.

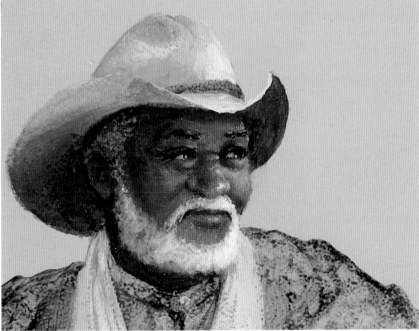

Step 10

With a no. 1 liner, highlight the beard with mix 2 + more Warm White. Add a touch of Ultramarine Blue as you reach the medium and dark areas of the beard and on the side plane of the face to suggest hair at the hairline. Keep this color darker in tone and very subtle.

With a no. 1 liner, highlight the face with Burnt Sienna + Amethyst + a touch of Warm White + Yellow Oxide. For the final highlight, add a bit more Amethyst to the previous mix. With a no. 6 filbert, add random dots of Amethyst on the shirt to harmonize, and smudge them while wet.

Side View

 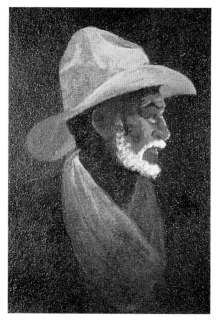

Step 1

Paint the features with mix 5 + water on a no. 1 liner. Add a bit more Purple Madder to the mix and paint the shadow areas with a no. 6 or no. 8 filbert. Soften the edges.

Apply Burnt Sienna + water to the light and mid-value areas of the face with the no. 6 or no. 8 filbert. Use less water in the light areas.

Base the top of the hat and lighter areas of the brim with mix 2 on a ½-inch (12 mm) flat. Gradually blend mix 3 + mix 4 in the dark areas of the hat, using a bit more Ultramarine Blue in the shaded areas and more Cadmium Orange with mix 2 in the reflected light areas on the hat brim.

With a no. 6 liner, paint the front of the mustache and beard with mix 2, picking up mix 3 and 4 in the side plane in front of the ear and along the jaw line. Also add a bit of this color to the back side of the mustache.

Step 2

Paint the light and midtone areas of the face again with Burnt Sienna + water on a no. 6 or no. 8 filbert, using a bit more paint in the light areas. Paint the lips, bottom of the nose and the ear with Napthol Red Light + a touch of Amethyst + Burnt Sienna. Use a no. 1 liner

With mix 5 + water, paint the eyebrows, eye opening line, the pupil, the nostril and the shadow of the nose with a no. 1 liner. The pupil will not be round, but rather an oval shape, in this side view.

Using a ½-inch (12 mm) flat, paint the shirt with Hookers Green + Ultramarine Blue + water. Paint the neckerchief with mix 2, and shade it with mix 3 + Hookers Green + Ultramarine Blue + water.

Step 3

Highlight the face with Burnt Sienna + Amethyst on a no. 1 liner. Paint the lower cheek, lips, bottom of the nose and the ear with Napthol Red Light + Amethyst + Burnt Sienna, using a no. 6 liner. Deepen the shadow areas as needed with Purple Madder + Brown Earth on a no. 6 filbert.

Paint the eye and brow with mix 5 and a no.1 liner. With the same brush, highlight the face further with mix 2 + more Ultramarine Blue.

Soften over the Amethyst + Burnt Sienna areas; however, do not carry this color as far as the shadow areas.

Paint the mustache and beard again with mix 2 and the no. 1 liner, adding more Warm White + Yellow Oxide on the front and lightest areas.

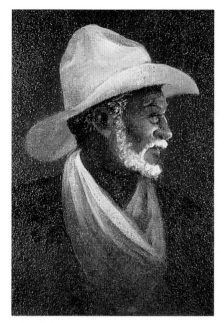

Step 4

Strengthen the color in the shadow areas of the hat with mix 3 on a no. 6 filbert. Paint the hat brim with mix 2, adding more Cadmium Orange in the reflective areas. Use a ½-inch (12 mm) flat. Add mix 3 to the neckerchief with a no. 1 liner; also add a touch to the eyebrows.

With a no. 6 filbert, paint the medium areas of the face again with Raw Sienna + Burnt Sienna + water. Soften this color before reaching the shaded areas, confining it only to the light and mid-value areas.

Strengthen the inside of the mouth with Purple Madder + Brown Earth on a no. 1 liner, and add a bit to the eye creases.

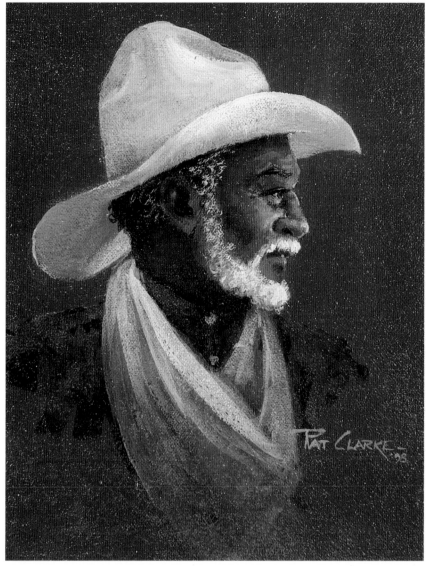

Step 5

Highlight the shirt with Ultramarine Blue + Hookers Green + a touch of Warm White on a ½-inch (12 mm) flat.

Add the final highlights to the hat with mix 2 + Warm White + Yellow Oxide, again using the ½-inch (12 mm) flat.

Add more Ultramarine Blue to mix 3 in the shaded areas as necessary, using a no. 6 filbert.

Paint the highlight on the cheek next to the eye with Burnt Sienna + Raw Sienna + water. Use a no. 6 filbert. With a no. 6 liner, add Burnt Sienna + Raw Sienna + Cadmium Orange on the nose and forehead, and soften.

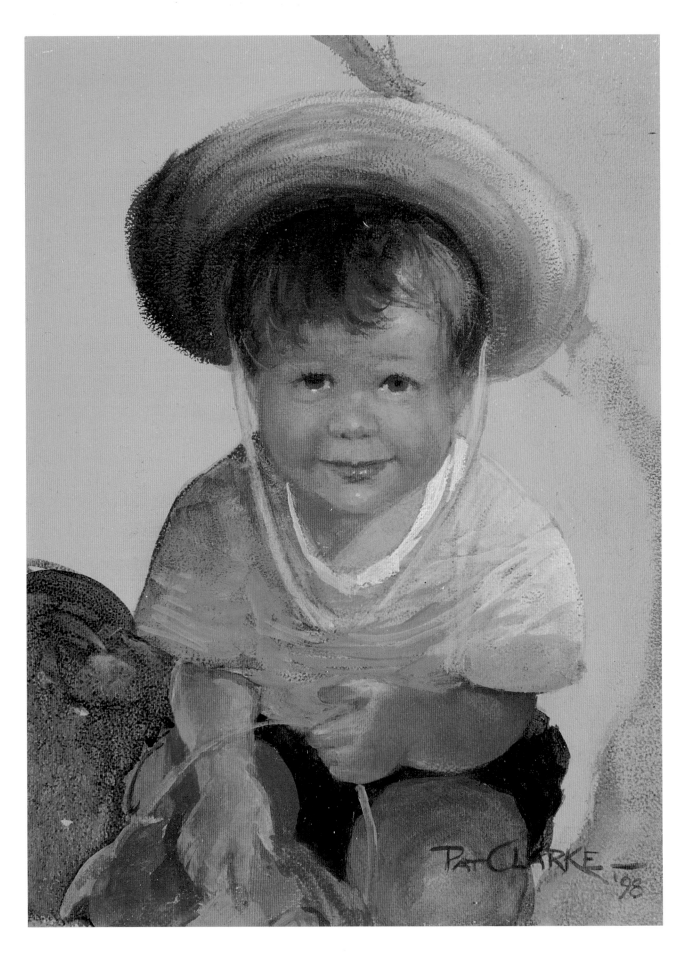

Adam–A Full Portrait of a Young Boy

If you've followed along with the previous painting projects, you should now have the confidence to begin adding more of the figure to your portraits. I have kept the size small—this portrait is only 8" x 10" (20.3 cm x 25.4 cm)—to make the project less intimidating. In addition, the head is front view and almost level—an easy angle to paint.

Preparing Your Surface

Using a sponge roller, coat the surface with one coat of gesso, and dry. Then coat the surface with a neutral tone of Vellum acrylic background paint, applied with a sponge roller. Transfer the pattern as usual, including all the details for the lower body.

Mixtures

Mix 1 Basic Flesh Tone
Titanium White + Gold Oxide

Mix 2 Shading Flesh Tone
Norwegian Orange + Dioxazine Purple + a touch of Gold Oxide

Mix 3 Blush Tone
mix 1 + Napthol Red Light + a touch of Vermilion

Mix 4 Highlight Flesh Tone
Titanium White + a touch of mix 1 + a touch of Cadmium Yellow Mid

Mix 5 Neutral Tone
(Use if the face color needs to be toned down.)
equal parts of Amethyst + Moss Green

Materials

Jo Sonja's Artist's Gouache
- Titanium White
- Cadmium Yellow Mid
- Yellow Oxide
- Gold Oxide
- Norwegian Orange
- Vermilion
- Napthol Red Light
- Burgundy
- Dioxazine Purple
- Prussian Blue
- Ultramarine Blue
- Brown Earth
- Amethyst
- Moss Green

Jo Sonja's Artists' Quality Background Color
Vellum

Brushes
- no. 6 and no. 8 filberts
- no. 1 and no. 6 liners
- no. 6, ½-inch (12 mm) and 1-inch (25 mm) flats

Surface
8" x 10" (20.3 cm x 25.4 cm) Masonite board

Other
supplies listed on page 8

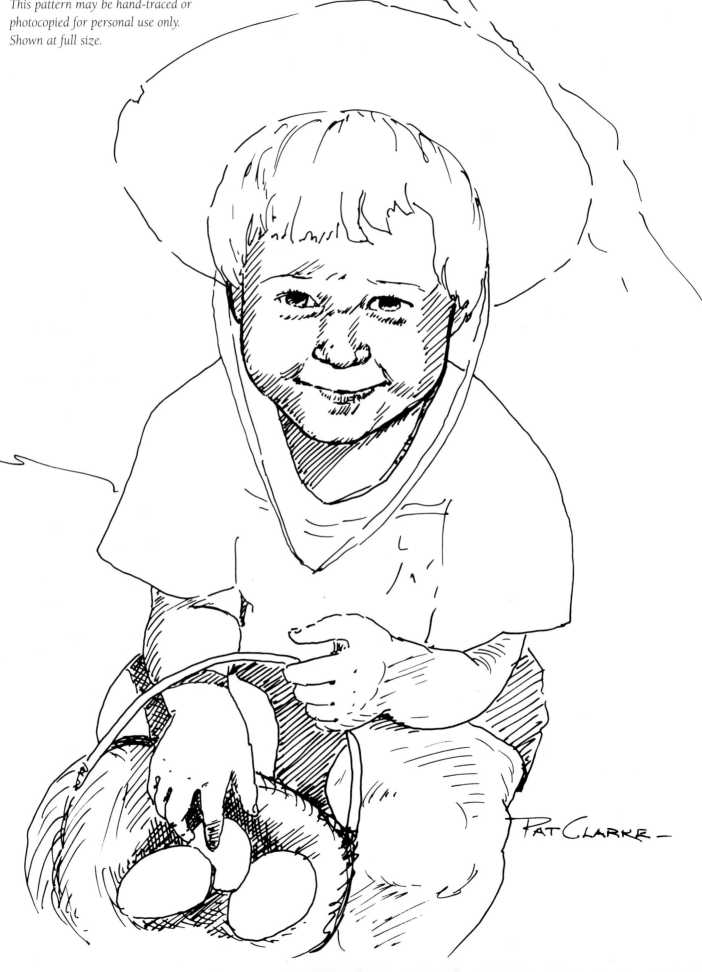

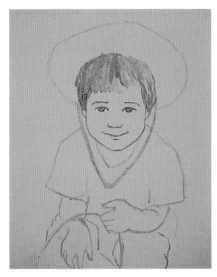 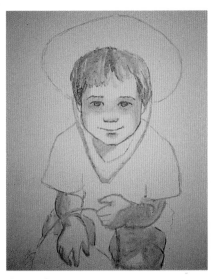

Step 1

Load a no. 1 liner brush with mix 2 + water and lightly outline the main lines of the face—including the features, the upper eyelids, the nose and nostril suggestions and the center line of the mouth. Fill in the entire iris. Also outline the hands, arms, legs and clothing. Dry.

Step 2

Moisten the face with water and stroke lightly to even the water out. With a no. 6 or 8 filbert brush and mix 2 + a touch of water, add the concave areas of the eyes. Quickly rinse the brush and blot. Overlap the edge of the shadow area with the dry brush and, with gentle pressure, soften only the edge to remove any hard lines; avoid the center of the dark area. Also add the side planes of the face, the nose shadow and the shadow under the lower lip with mix 2 + water, softening all edges. Hold the brush high on the handle and use the flat of the brush to skim lightly over the surface. It is best not to enter the center of the darker areas; soften only the outer edge so no hard edge occurs.

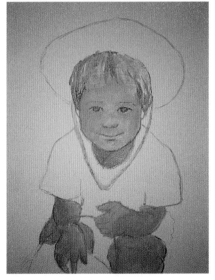 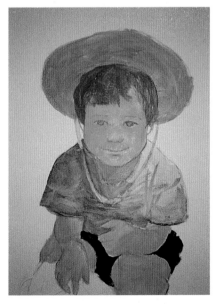

Step 4

Paint the hair with mix 2 + a touch more Dioxazine Purple, using a no. 6 liner. Soften with a no. 6 or no. 8 filbert. Paint the hat with Gold Oxide on a ½-inch (12 mm) flat. Paint the left side of the shirt with Ultramarine Blue + Brown Earth + water. Add more water when painting the right side to lighten the value. Paint the pants with Ultramarine Blue + Brown Earth + a touch of water—use less water in this mix for a darker tone.

Step 3

Paint over the entire face with a medium-value skin tone made with mix 1 + a touch of mix 2 + a touch of water. Use a no. 6 or no. 8 filbert.

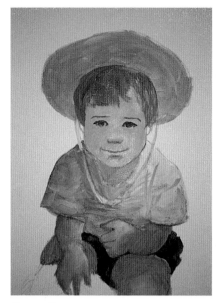

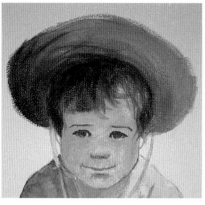

Step 6

Using a ½-inch (12 mm) flat, shade the hat, beginning with mix 2 on the left and moving into Gold Oxide in the center, then into Yellow Oxide on the right, using a dirty brush and working wet-into-wet. Deepen the hair where it merges with the hat, using Dioxazine Purple + Brown Earth + water; use more water to fade the tone on the hat and the front of the hair. Dry, apply glazing medium and dry again.

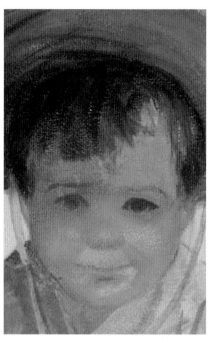

Step 5

Using a no. 1 liner, strengthen the line on the top of the eye and the sides of the iris with mix 2 + a touch of water. Fill in the top half of the iris, then soften with water at the bottom. Use mix 2 + water to suggest brows; also shade a bit of this mix in the corners of the eyes with a no. 6 filbert. Add more shading to the hands and legs with mix 2 + a touch of Napthol Red Light + a touch of water. Soften.

Step 7

Add retarder to the face and stroke until satiny in appearance. Add mix 3 to the cheeks, nose and chin. Blend mix 1 into this tone. Use mix 2 + mix 3 on the side planes of the face and within the eye cavity. Soften. When dry, apply glazing medium and dry again with a hair dryer.

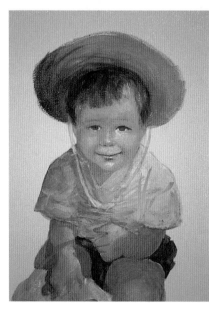

Step 8

Strengthen the eye line and iris with Brown Earth + water on a no. 1 liner. Add an orange tone made from a touch of Vermilion + Norwegian Orange to the bottom of the iris. Paint the white of the eyes with a blue-gray tone of mix 1 + a touch of Ultramarine Blue on a no. 1 liner. Strengthen the cheeks, chin and nose with a more intense blush tone of mix 3 + more Napthol Red Light + a touch of Vermilion, using a no. 6 or no. 8 filbert. Strengthen the mouth line in the center and under the lower lip with Burgundy + Brown Earth. Paint the basket with Yellow Oxide + Gold Oxide on a ½-inch (12 mm) flat. Paint the lavender egg with Ultramarine Blue + a touch of Amethyst + Titanium White, the blue egg with Ultramarine Blue + mix 4, and the yellow egg with Cadmium Yellow Mid + Yellow Oxide. Dry. Apply glazing medium, and dry with a hair dryer.

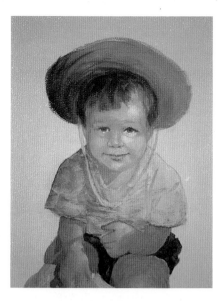

Step 9

Coat the painting with retarder. Apply mix 1 to the light area, and merge this color into the more intense blush tone. While this is still wet, begin highlighting with mix 1 + mix 4 on the cheeks, under the eyes and on the nose and chin. Strengthen the lip color with mix 3 + more Napthol Red Light on a no. 1 liner. Strengthen the top line of the eyes with Brown Earth + Ultramarine Blue + a touch of water, adding pupils and a suggestion of lashes. If necessary, add more Vermilion + Norwegian Orange to the lower iris with a no. 1 liner. Highlight the corners of the eyes and touch on the lower lid next to the iris with Titanium White + Ultramarine Blue. Dry, apply glazing medium, and dry with a hair dryer.

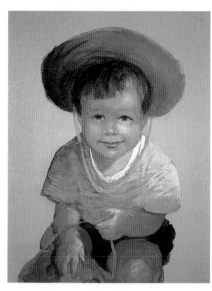

Step 10

Paint the hands with mix 2 + mix 3 + more Napthol Red Light. Into this color, blend mix 3, then mix 1 + a touch of mix 4. Use a no. 6 flat and Ultramarine Blue + Brown Earth + a touch of water to define the negative area around the hand.

Using the chisel edge of a ½-inch (12 mm) flat, add some medium-value blue stripes in the dark area of the shirt with Ultramarine Blue + Titanium White + a touch of Vermilion. Add some light-toned stripes with Titanium White + Yellow Oxide + a touch of Ultramarine Blue. Highlight the light side of the shirt with Yellow Oxide + Titanium White + a touch of Ultramarine Blue. Paint the trim on the right side of the collar with Titanium White + Yellow Oxide. Add a touch of Ultramarine Blue to the mix for the left side of the collar.

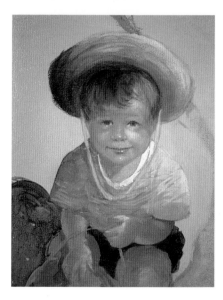

Step 11

Using a no. 8 filbert, add tree limb shadows in the background with Brown Earth + Dioxazine Purple + water. Add a touch of Ultramarine Blue to this mix to paint the shadow of the child on the left.

Highlight the hat with Yellow Oxide + Titanium White. With a no. 6 liner, add more darks to the hair with Brown Earth + Dioxazine Purple, add midtones with Yellow Oxide + Gold Oxide and add the final highlights to the hair with Yellow Oxide + Titanium White. Define the strap hanging from the hat with Yellow Oxide + Titanium White.

Strengthen the basket handles with Titanium White + Yellow Oxide on a no. 6 liner.

Add a touch more blush to the left sides of the cheeks with mix 3 + Napthol Red Light + a touch of Burgundy. Use a no. 6 or no. 8 filbert. Add a bit of mix 5 + a more intense blush tone on the side of the face and nose to neutralize the red tone. Add a bit of mix 1 + a touch of Ultramarine Blue to the cheek highlight on the left, using a no. 6 filbert. Soften with your finger. Add strong highlights to the forehead, nose, lips and chin with mix 4, using a no. 1 liner. Soften the edges. Add reflected lights on the left side of the left arm and hand and on the underside of the right arm with Titanium White + Ultramarine Blue. Use a no. 6 filbert brush.

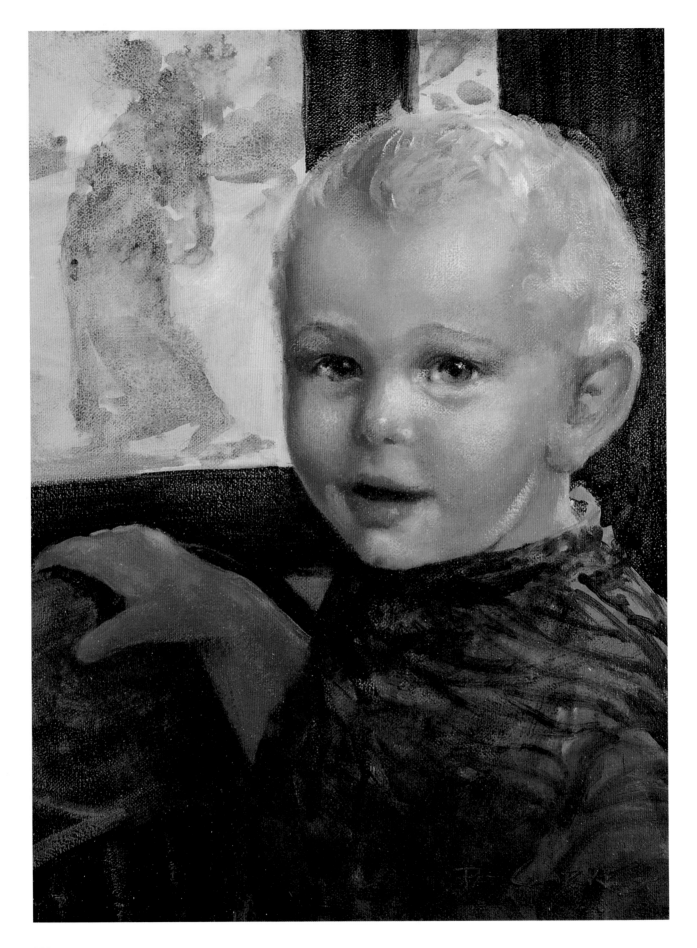

The Toddler–A Portrait on Canvas

In the last project, we painted more of the figure and added a suggestion of objects in the background. This project takes you a step further with a more fully developed background. To add to the challenge, I've painted this portrait on canvas, and made it a bit larger than the previous surfaces.

Preparing Your Surface

If you purchase a preprimed and stretched canvas (available at most art supply stores), no preparation is needed prior to the basecoat. Coat the surface with a neutral tone of Vellum acrylic background paint, applied with a sponge roller. Dry.

The pattern on page 114 has been reduced to fit this book. Enlarge the pattern on a photocopier to return it to the correct size for an 11" x 14" (27.9 cm x 35.6 cm) canvas, then transfer the pattern lines as usual.

Mixtures

Mix 1 Basic Flesh Tone
Titanium White + Gold Oxide

Mix 2 Shading Flesh Tone
Norwegian Orange + Dioxazine Purple + a touch of Gold Oxide

Mix 3 Blush Tone
mix 1 + Napthol Red Light + a touch of Vermilion

Mix 4 Highlight Flesh Tone
Titanium White + a touch of mix 1 + a touch of Cadmium Yellow Mid

Mix 5 Neutral Tone
(Use if the face color needs to be toned down.)
equal parts of Amethyst + Moss Green

Materials

Jo Sonja's Artist's Gouache
- Titanium White
- Cadmium Yellow Mid
- Yellow Oxide
- Gold Oxide
- Norwegian Orange
- Vermilion
- Napthol Red Light
- Napthol Crimson
- Burgundy
- Dioxazine Purple
- Prussian Blue
- Ultramarine Blue
- Brown Earth
- Amethyst
- Moss Green
- Carbon Black

Jo Sonja's Artists' Quality Background Color
Vellum

Brushes
- no. 6, no. 8, no. 10 and no. 12 filberts
- no. 1 and no. 6 liners
- no. 6, ½-inch (12 mm) and 1-inch (25 mm) flats

Surface
11" x 14" (27.9 cm x 35.6 cm) preprimed and stretched canvas

Other
- supplies listed on page 8
- Jo Sonja's Wood Stain Glaze, Transparent Oxide Red

DIRECTIONAL GUIDE

Since this portrait is a bit more involved than the previous projects, I've included this directional guide to help you understand the energy of the strokes. This will help you to feel the form of the face.

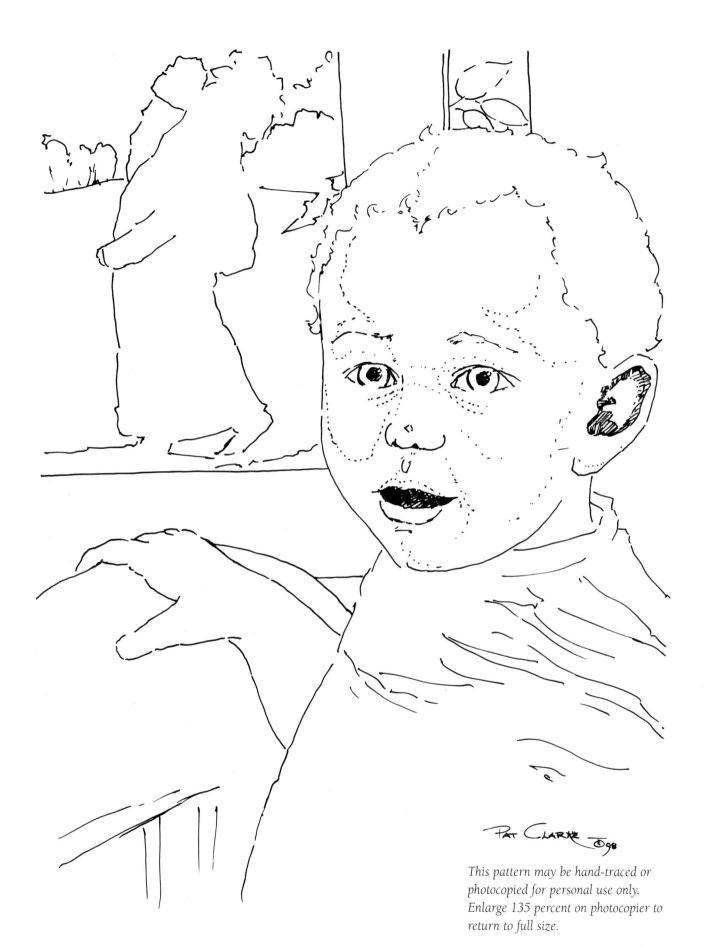

This pattern may be hand-traced or photocopied for personal use only. Enlarge 135 percent on photocopier to return to full size.

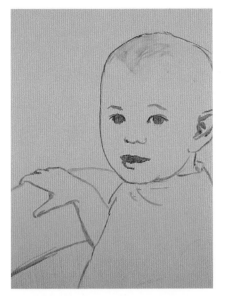

Step 1

With mix 2 + water on a no.1 liner brush, lightly outline the main lines of the face, including the features, hand, arm and clothing.

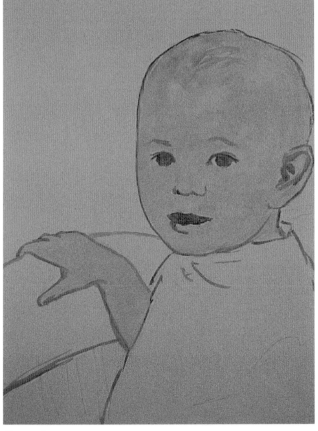

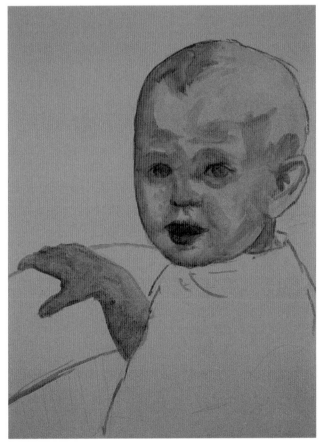

Step 2

Paint over the entire face and the arm with mix 1.

Step 3

Using a large no. 10 or no. 12 filbert brush loaded with mix 2 + water, paint the shaded and receding areas of the face. Soften the lines, making sure there are no hard edges. With a no. 6 liner, add the upper lip with the same mix, working up from the center of the mouth. Note the stroke direction from the inside of the mouth on the left side of the lower lip in the directional guide on page 113.

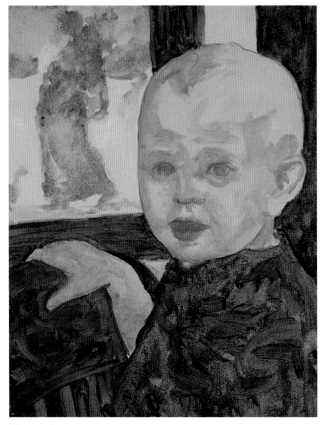

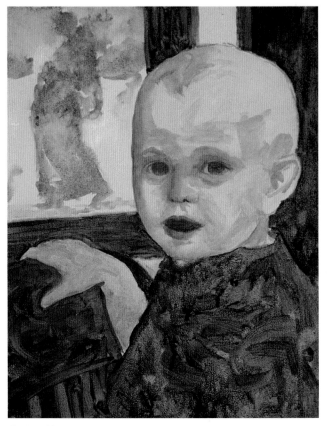

Step 4

Add the shirt color with Ultramarine Blue + Brown Earth + a touch of Dioxazine Purple on a no. 12 filbert.

Use a 1-inch flat (25 mm) to paint the chair and the dark area behind the head with Brown Earth + Ultramarine Blue + a touch of Dioxazine Purple + water, leaning toward a brown tone. Use less water than on the face.

Using a 1-inch (25 mm) flat, paint the picture frame in the background with Ultramarine Blue + Brown Earth + a touch of Dioxazine Purple + a touch of water. Add a bit of Dioxazine Purple + a touch of Burgundy at the outer edge on the side. Soften the inside edge of the bottom of the frame.

Using a no. 8 filbert, paint the figure (which is actually a Santa) in the picture behind the toddler with Ultramarine Blue + Brown Earth + a touch of Dioxazine Purple + water; use more water than previously to keep the figure light in value and soft. Add more brown tones with the same mix + a bit of mix 2, leaning more toward the brown tones. Use touches of mix 2 + water for the figure's face and mix 4 + water for the beard and snow. Keep soft.

Step 5

Deepen the eye cavity and dark areas on the face, nose and lips with mix 2 + Transparent Oxide Red, using a no. 10 filbert. When dry, deepen the lines above the eye and the outer iris edges with Brown Earth + Prussian Blue + a touch of Transparent Oxide Red + a touch of water on a no. 1 liner. Then fill in the iris halfway down from the top and soften the bottom edge. Add nostril suggestions and fill in the mouth opening with Burgundy + Brown Earth + water. Dry, apply glazing medium to the entire surface and dry again with a hair dryer.

Painting a Simpler Background

Because it is important to gauge values collectively as you are painting the face, if background interest is to be included, it should be painted at this stage so the values may be read accordingly.

If you'd like to paint a simpler background, just move the toddler a bit more toward the center and use Vellum as the background color. The portrait will still read well and will be in a bit lighter key.

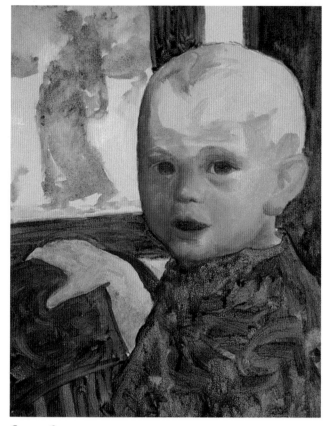
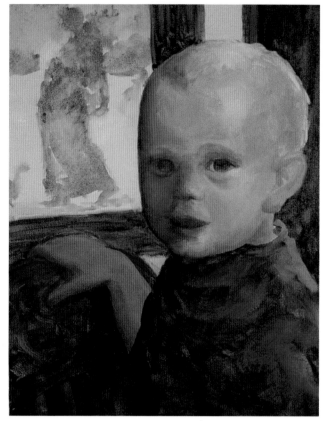

Step 6

Use a no. 12 filbert for this step. Apply retarder over the entire face and a bit beyond with a large brush. Stroke until the retarder looks satiny and covers all areas evenly. Dress the filbert brush with a bit of retarder, blot, then pick up mix 3 and apply it to the right cheek and ear. Wipe the brush on a dry paper towel, pick up mix 1 and blend it into the mix 3 areas. Continue with mix 1, adding a bit of Moss Green into the upper cheek. Blend a lavender tone into the side plane of the face next to the ear with mix 1 + a touch of Dioxazine Purple. Add more Napthol Red Light + a touch of Vermilion to mix 3 for the left cheek and chin.

Blot and wipe the brush, pick up a touch more retarder, blot again, then add more shading with mix 2 + Transparent Oxide Red + a touch of Dioxazine Purple. Soften this color into the dark areas, then blend in mix 3 + more Napthol Red Light.

Larger faces have to be done in segments; the above picture shows how far I was able to paint before the paint felt tacky. When this happens, stop painting and dry with a hair dryer. Paint over the surface with glazing medium, then dry again with the hair dryer and add more retarder. Continue to add more color as necessary.

Step 7

With a no. 10 filbert, paint the hand with mix 2 + mix 3 + more Napthol Red Light + a touch of Vermilion (I will refer to this mixture as the "punched-up blush tone"). Shade the hand with Burgundy + Brown Earth. Add highlights with mix 3 + a touch of mix 1. Add a wash of Prussian Blue + Brown Earth as a shadow on the chair next to the hand.

Paint the dark areas of the shirt with Prussian Blue + a touch of Brown Earth. Highlight with Titanium White + Prussian Blue + a touch of Cadmium Yellow Mid. Use a ½-inch (12 mm) flat.

Stroke retarder on the forehead and the right side plane of the face. With a no. 12 filbert, add the punched-up blush tone next to the dark areas on the cheeks and nose. Add more mix 1. Blend this color, then add mix 1 + Moss Green just under the temple area and blend. Add mix 1 + a touch of Dioxazine Purple (lavender tone) to the side area of the temple, next to the highlight. Highlight with mix 4 + a touch of Yellow Oxide.

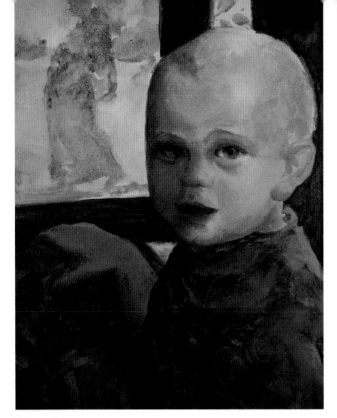 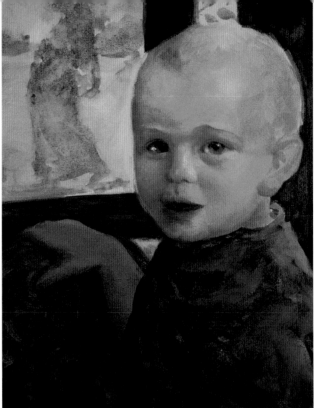

Step 8

With a no. 10 or no. 12 filbert, deepen the dark areas, as necessary, with Brown Earth + Dioxazine Purple + a touch of Burgundy + water.

Strengthen the eye opening line and the line above the eye and add a pupil with a bit less water and more paint, using a no. 1 liner. Deepen the iris on the side edges (not the bottom edge) with the above mix. Add eyebrows with the above mix + a touch of Transparent Oxide Red + water.

With a no. 6 liner, paint the lower iris with a blue tone of mix 4 + a touch of Prussian Blue, and add a touch to the eyeball area next to the iris. Allow a bit of the brown tone to show at the top of the iris. Highlight the right eye with mix 4, then soften. Use mix 4 + a touch of Dioxazine Purple to highlight the left eye. Use a no. 1 liner.

Deepen the lips with the punched-up blush tone, then add another wash of Burgundy + Brown Earth + a touch of Dioxazine Purple with a no. 6 liner.

With a 1-inch (25 mm) flat, add another wash over the woodwork and the picture frame with layers of Ultramarine Blue + Brown Earth + a touch of Dioxazine Purple + water; come over the edge of the child's head about ⅛-inch (.32 cm). Wash over the chair with Transparent Oxide Red near the chair top and right in front of the shirt.

Add stencil-type leaves above the child's head on the wall with Gold Oxide + water, using a no. 8 filbert.

Step 9

After the last step, I viewed my painting from a distance to check my progress. I decided that the left side of the face had become a bit too dark in value once it dried. Also, a crisp edge was visible on the left side. The head and face also appeared larger than in my original drawing. (This is the time I call the "ugly stage.")

I first corrected the color and values with mix 1 + mix 3 + more Napthol Red Light + a touch of Vermilion (the punched-up blush tone), adding mix 2 as necessary. I used a dry no. 12 filbert to skim over the areas I felt were too dark. Then, I used the appropriate background colors to trim about ⅛-inch (.32 cm) from the left side and top of the head. Finally, I raised the brow on the left with mix 2 + a touch of Brown Earth and brought the punched-up blush tone over a bit farther to the right. While I was working around the eyes, I added the highlights to the eyes with mix 4.

I prefer to keep my colors a bit brighter than too dull, because I know I can neutralize the color with a wash of mix 5 to tone it down.

When painting faces, especially young children, I am always more concerned that colors and values blend gradually and leave no hard edges than I am about the actual colors. Lines call attention and are difficult to correct. To avoid them, soften edges while the paint is wet.

Only when wrinkles are meant to be depicted should there be any hint of lines (and even then they will have varied values so as not to depict a hard edge).

Stepping back often to view the painting as a whole helps me to see these problems before I go too far.

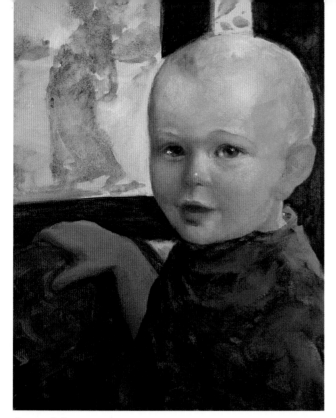

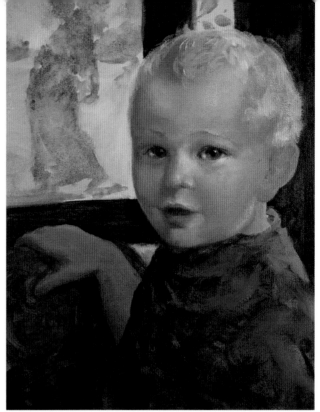

Step 10

With the no. 12 filbert, moisten the surface with water, then strengthen the blush tone on the ear and on the right cheek next to the nose with Napthol Red Light + a touch of Vermilion.

I also corrected the mouth shape and began highlighting the nose with mix 1 + a touch of mix 4 on a no. 6 liner. Soften these edges while they are wet. Dry, apply glazing medium, and dry with a hair dryer.

Step 11

Add retarder to the cheek, then begin highlighting under the eye and on the cheek with mix 4 + a touch of Yellow Oxide. Also use this color for the reflected light on the lower right cheek next to the neck and on the back of the neck. Use a no. 12 filbert.

On the left cheek and under the brow, add a lavender-toned reflected light of Yellow Oxide + a touch of Dioxazine Purple + mix 3, using a no. 12 filbert.

With a no. 1 liner, add a touch of Brown Earth to the curve of the left eye at the outside corner to warm within the cool area.

Strengthen the highlights on the nose and lip with mix 4 and a no. 1 liner.

Use a no. 10 filbert for the remainder of this step. Deepen the value of the hair on the center top with Yellow Oxide + a touch of Dioxazine Purple + a touch of mix 3 (a lavender tone), bringing it over to the side plane on the right above the ear and temple area.

Highlight the hair with mix 4 + Yellow Oxide, bringing this color over the edges of the head and creating wispy strokes on the upper head.

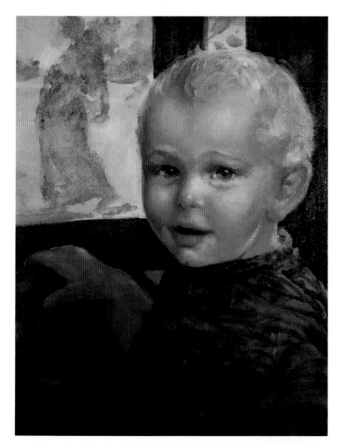

Step 12

Refine the highlight areas on the face by adding more mix 4 and smudging with your finger. Refine the shirt by adding a dark wash of Prussian Blue + Brown Earth + a touch of Dioxazine Purple over the dark areas. Use this mix to add the suggestion of stripes on the shirt with a no. 12 filbert.

Paint the highlights on the chair with Norwegian Orange + a touch of Amethyst on a dry ½-inch (12 mm) flat. Don't add too much detail here.

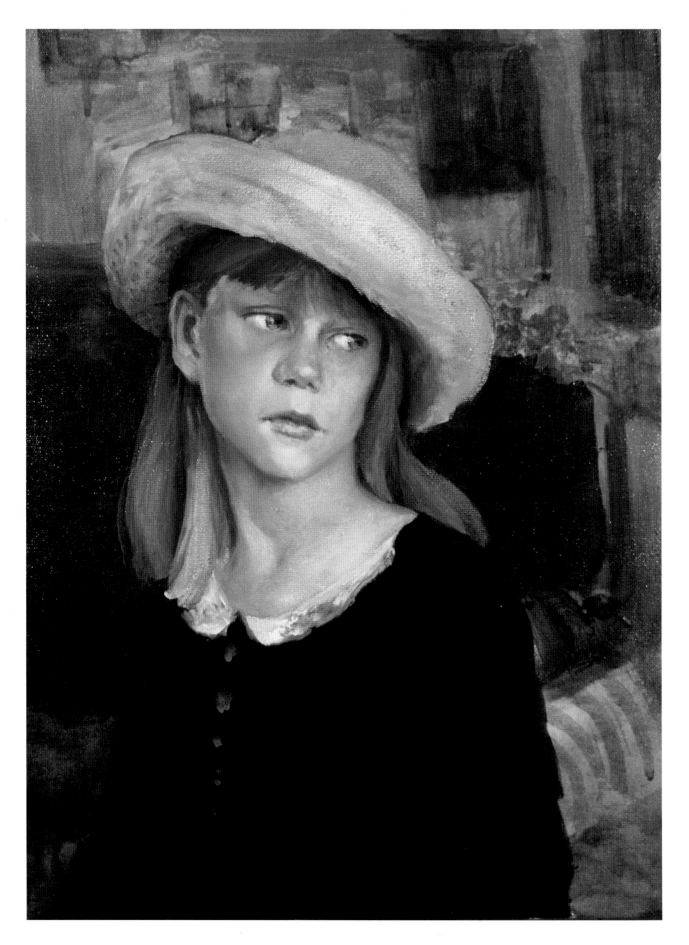

Jenny–A Young Girl in a Hat

Preparing Your Surface

I painted this project on preprimed canvas with no other preparation. It is necessary for the white of the canvas to show through the background colors in some areas, so you will begin painting on the bare canvas.

This portrait begins in the same way as the other projects, with the outlining of the face and other elements. However, since this portrait has so many dark values, it is important to set the stage with the background colors and values very early in the painting. You will still mix water with the paint when painting the background, but when the area you're painting is very dark, use more paint and less water.

Enlarge and transfer the design as you did in the previous project.

Mixtures

Mix 1 Basic Flesh Tone
Titanium White + Gold Oxide

Mix 2 Shading Flesh Tone
Norwegian Orange + Dioxazine Purple + a touch of Gold Oxide

Mix 3 Blush Tone
mix 1 + Napthol Red Light + a touch of Vermilion

Mix 4 Highlight Flesh Tone
Titanium White + a touch of mix 1 + a touch of Cadmium Yellow Mid

Mix 5 Neutral Tone
(Use if the face color needs to be toned down.)
equal parts of Amethyst + Moss Green

Materials

Jo Sonja's Artist's Gouache
- Titanium White
- Cadmium Yellow Mid
- Yellow Oxide
- Gold Oxide
- Norwegian Orange
- Vermilion
- Napthol Red Light
- Napthol Crimson
- Burgundy
- Dioxazine Purple
- Prussian Blue
- Ultramarine Blue
- Cobalt Blue
- Brown Earth
- Amethyst
- Moss Green
- Carbon Black

Brushes
- no. 6, no. 8 and no. 10 filberts
- no. 1 and no. 6 liners
- no. 6, ½-inch (12 mm) and 1-inch (25 mm) flats

Surface
11" x 14" (27.9 cm x 35.6 cm) preprimed and stretched canvas

Others
- supplies listed on page 8
- Jo Sonja's Wood Stain Glaze, Transparent Oxide Red

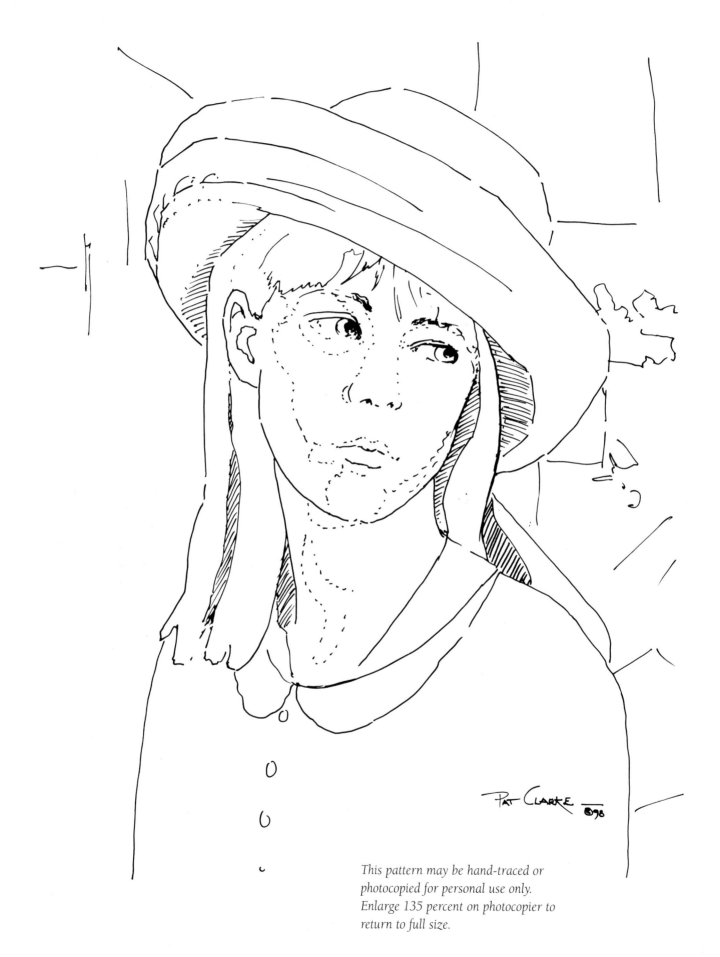

This pattern may be hand-traced or photocopied for personal use only. Enlarge 135 percent on photocopier to return to full size.

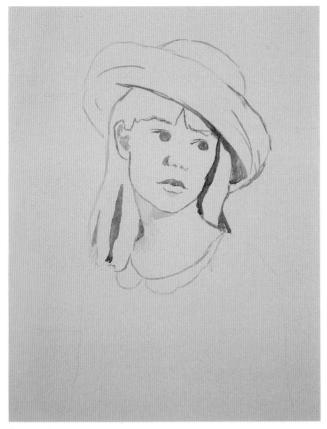

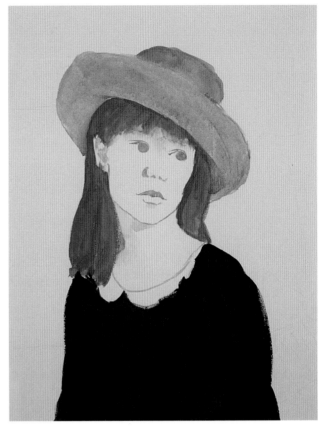

Step 1

Outline the face and features and fill in the iris with a no. 1 liner brush loaded with mix 2 + water. Use mix 2 with a bit less water to fill in the dark areas of the hair and under the hat with a no. 10 filbert.

Step 2

With a 1-inch (25 mm) flat, paint the hat with Yellow Oxide + Gold Oxide + water. Paint the dress with Prussian Blue + Carbon Black + a touch of Dioxazine Purple + water. It may take two coats to get opaque coverage. Dry in between layers. Paint the hair with Norwegian Orange + a touch of water on a no. 12 filbert.

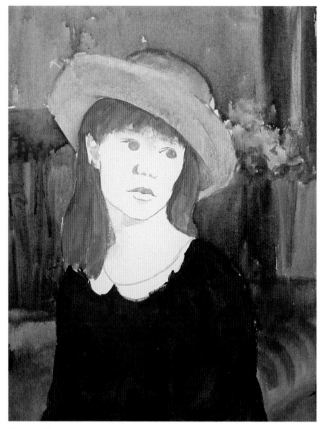 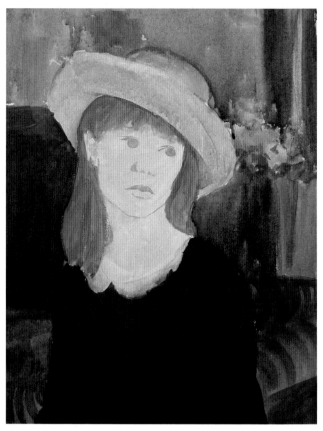

Step 3

Using a 1-inch (25 mm) flat brush, begin painting the upper left corner of the background with Transparent Red Oxide + Prussian Blue + water. Merge this color to the right. Use a bit more paint and less water for darker areas and lean a bit toward a blue tone.

Paint the flowers with Napthol Crimson + water on a no. 12 filbert.

Paint the area next to the girl on the right with Prussian Blue + Carbon Black + a touch of water. Use a 1-inch (25 mm) flat. Occasionally leave light areas open.

Paint the bottom right with Ultramarine Blue + Transparent Red Oxide + water. This color should be transparent. Dry. Add more paint to this mix for the stripes on the back of the sofa using the chisel edge of a no. 12 filbert.

Paint the left side dark area with Prussian Blue + Carbon Black + a touch of Dioxazine Purple on a 1-inch (25 mm) flat. Fade this color into Prussian Blue + Transparent Red Oxide + water. Dry.

Step 4

Add a wash of Napthol Crimson + water at the left top and center, using the 1-inch (25 mm) flat. Add Cobalt Blue to the open light areas on the right. Add more washes of Prussian Blue + Carbon Black for the dark areas and stripes.

Paint a wash of mix 1 on the face, neck and chest with a no. 12 filbert. Dry.

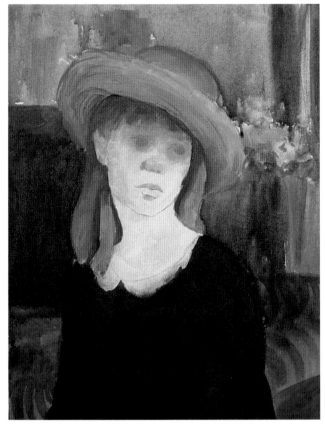

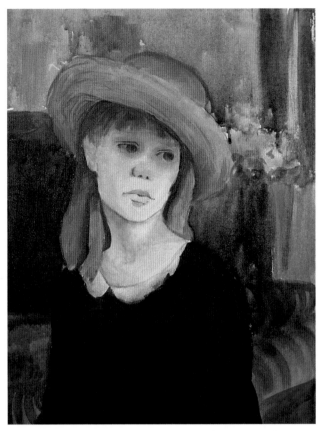

Step 5

Place dark areas on the face with mix 2 + water on a no. 10 or no. 12 filbert. Soften the edges on the cheek. Dry. Coat with glazing medium and dry again.

Base the hat again with Yellow Oxide + Gold Oxide on a 1-inch (25 mm) flat, keeping the Gold Oxide next to the hair and the Yellow Oxide at the edge of the brim. Apply chisel-edge strokes throughout the hat to simulate the texture of straw. When dry, deepen the dark areas on the hat next to the hair with mix 2 + a touch of Dioxazine Purple. Continue this color into the dark areas of the hair. Dry, then coat with glazing medium and dry again.

Step 6

Outline the eye opening and the line above the eye with mix 2 on a no. 1 liner. Fill in the iris halfway down, and soften the bottom edge. Strengthen the nostril, the side of the nose, the center line of the mouth and the lower lip with Burgundy + Brown Earth on a no. 12 filbert. Soften. Shade the neck with mix 2 + water, and soften. Dry, apply glazing medium and dry again.

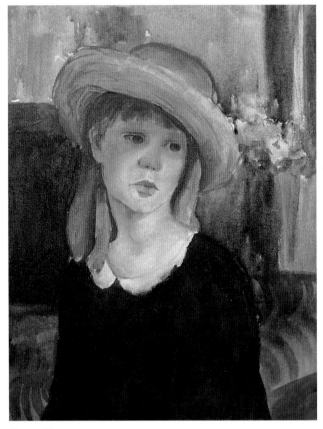

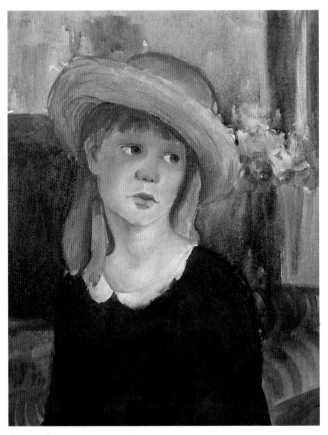

Step 7

Coat the face with retarder, stroke until satiny (no puddles) and smooth. Dress a no. 6 or no. 12 filbert brush with retarder, blot, and apply mix 3 to the cheeks, nose, side planes of the face and the chin. Soften this color into mix 1.

Add mix 2 + mix 3 + more Napthol Red Light + a touch of Vermilion (punched-up blush tone) to the dark areas of the eyes. Use a no. 10 or no. 12 filbert.

Add a bit more Napthol Red Light with touches of Napthol Crimson to the left cheek. Punch the lips up with mix 3, adding a bit of Napthol Crimson to the top lip. Wash over the bottom lip with this color + water on a no. 6 liner.

Step 8

Paint the entire eyeball area with mix 1 + a touch of mix 2 on a no. 1 liner. To round the eyeball, over the previous mix apply Titanium White + Cobalt Blue to the eyeball next to the iris. Outline the top of the eye and the sides of the iris (not the bottom) and place the pupil in the center of the iris with Brown Earth + a touch of Prussian Blue + a touch of water.

Reestablish the darker areas of the nostrils and left side of nose with Burgundy + Brown Earth, using a no. 1 liner. Also add this mixture to the center of the mouth and lower lip, and soften.

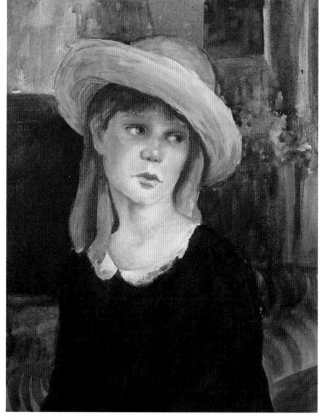

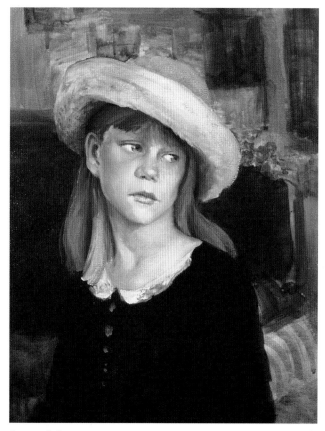

Step 9

Add a highlight to the iris and eyeball area with Titanium White + Cobalt Blue on a no. 1 liner. Soften.

Add highlights to the face with mix 1 + mix 4, using a no. 10 or no. 12 filbert. Next add highlights with straight mix 4 on a no. 1 liner.

Deepen the dark areas on the hair with Dioxazine Purple + Burgundy + Brown Earth. Highlight the hat with Titanium White + Yellow Oxide on a 1-inch (25 mm) flat. Add reflected light areas of Titanium White + Cobalt Blue. Soften.

Deepen areas of the background, if necessary, with washes of Prussian Blue + Burgundy and Prussian Blue + Cobalt Blue + Transparent Red Oxide. Use a 1-inch (25 mm) flat.

Step 10

In this step I refined any areas of value that needed to be strengthened or softened by checking one value against another. For example, I strengthened the cheek color within the blush areas using mix 3 + more Napthol Red Light + more Vermilion. I also highlighted and softened the lips, reshaping them as I worked.

After refining and reshaping the eyes, I strengthened the darks within the eyes with Brown Earth + Prussian Blue. I also used this mix to fill in the pupil and outline the iris and lashes. I strengthened the highlights within the eye with Titanium White + Cobalt Blue.

To complete the painting, I added another section of hair on the right shoulder, highlighted the collar with Titanium White, defined the neck shadows and high-lights and added further reflected light on the left side plane of the face with mix 1 + Cobalt Blue.

To check your final results, evaluate all the elements of the design as a whole. To do so, it is necessary to stand back from the painting, or even to view it in a mirror. This allows you to see the painting from a new viewpoint. Areas that need to be reshaped and values that need to be brightened, dulled or blended more smoothly become apparent.

Index